WONDER WOMAN

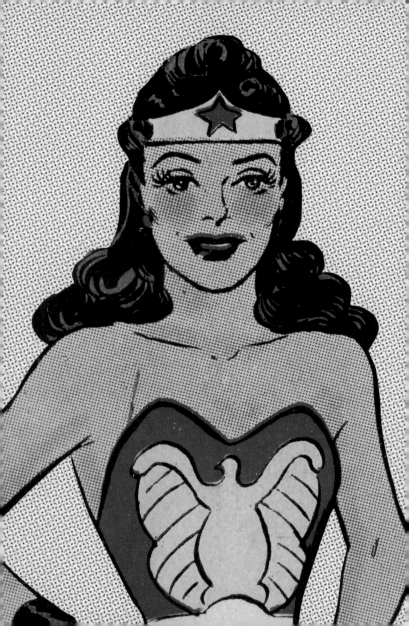

DC COMICS

THE LITTLE BOOK OF

Wonder Woman ™

Paul Levitz

TASCHEN

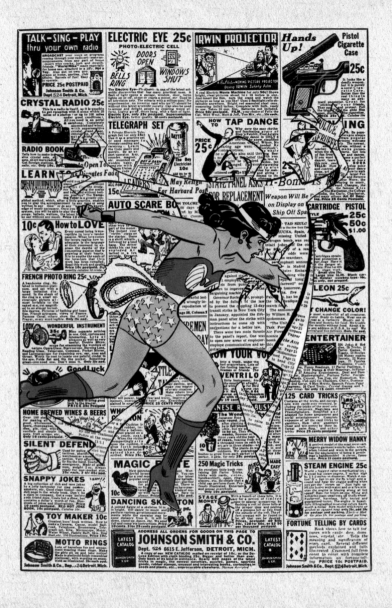

Why Do We Love Wonder Woman? 7

Warum lieben wir
Wonder Woman? 11

Pourquoi aimons-nous
Wonder Woman? 15

The Golden Age 18
1941–1956

The Silver Age 74
1956–1970

The Bronze Age 114
1970–1984

The Dark Age 158
1984–1998

The Modern Age 174
1998–2010

Credits 190

Acknowledgements 192

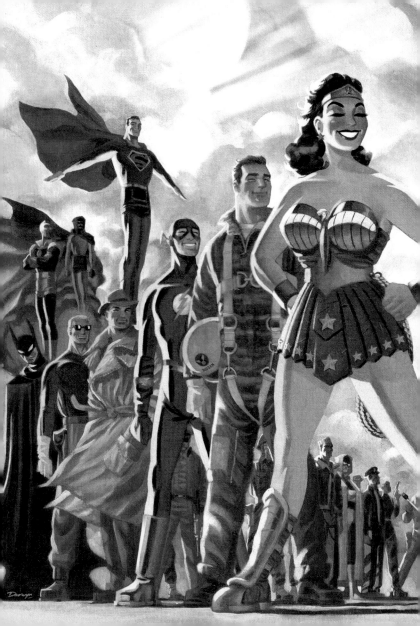

WHY DO WE LOVE WONDER WOMAN?

Is it because she's sure we would? There's something about a woman who radiates absolute confidence, and the Amazon Princess positively glows with it. Her creator built her that way. Not Queen Hippolyta but William Moulton Marston. He was a polymath, educated both as a lawyer and a psychologist, and his journey included becoming a novelist, self-help author, and magazine writer. Marston's article on the emerging importance of comics led to invitations to serve on DC Comics' Advisory Board (a group of luminaries designed to ward off criticism that comics were bad for children) as well as to write for the company. Marston combined his interests in mythology, social behavior, and women, and began writing a series of adventures that played off his theories of dominance and submission as social roles. H. G. Peter, a 61-year-old cartoonist with roots going back to *Judge*, a classic late-19th/early-20th-century magazine full of powerful political cartoons, brought a unique sensibility to the artwork as well. Beginning with her first appearance in late 1941, Marston would write or supervise all the Wonder Woman scripts until his death six years later, but Peter would continue drawing the series for almost two decades.

Wonder Woman premiered in *All-Star Comics* No. 8, immediately went on to star in a new anthology, *Sensation Comics*, and would add her own quarterly shortly thereafter. She was an instantly iconic figure, and equally controversial, with fierce debate among the Advisory Board members and psychologists about Wonder Woman's effect on children . . . the presumed audience of all comics at the time.

She had perfect accessories, too, as any stylish woman does: her lasso of truth (echoing Marston's scientific interests as an early

DC: THE NEW FRONTIER VOL. 1

Page 6: *Cover art, Darwyn Cooke, 2004.* Influenced by the art of
Alex Toth and Jack Kirby, Cooke conceived of *The New Frontier*
as an optimistic retelling of DC's Silver Age as if publishing events
had played out in real time. Here Superman arrives on the scene
in 1938 and Green Lantern Hal Jordan in 1959, set against the
historical backdrop of world events.

WONDER WOMAN No. 288

Opposite: *Interior, "Swan Song"; script, Roy Thomas; pencils,
Gene Colan; inks, Romeo Tanghal. February 1982.*

popularizer of the lie detector), her invisible plane, mental radio, and
bracelets flashing bullets away. And a tiara. How cool was that?

Is it because she has perfect timing? America first met Wonder
Woman in October 1941, just as the pre–World War II draft was yank-
ing men away from their jobs and into basic training. As she inspired
the country with her adventures, women were beginning to move into
unprecedented areas of the workforce to take the place of the missing
men. It was the era of Rosie the Riveter, and if DC Comics was silly
enough to leave her as the secretary to the Justice Society, she was still
a member of the first Super Hero group and more than their equal.

Her career had enough momentum from the '40s that she became
one of only three Super Heroes to survive the post-war collapse of the
genre, with their own comics continuously published until the Silver
Age of Comics revitalized it.

A generation later, her timing clicked again. Lynda Carter brought
Wonder Woman to life in a television show that went through several
identities, switching from World War II period stories to contemporary
ones, but somehow always connecting with the ideals the character
represented. Carter took her role as Wonder Woman seriously, resist-
ing the temptation to adopt a camp approach. "I played the humor in

a very human way, and it's sort of a dry way," she explained. "I tried to play her like a regular woman who just happened to have superhuman powers."

Is it because she hangs out with the coolest kids? Wonder Woman fan No. 1, Gloria Steinem, featured her on the first cover of *Ms.* magazine, and the television show served to further connect the Amazon Princess with the women's movement as an icon. If that wasn't enough, she became one of the key members of the *Super Friends,* holding her own with Superman and Batman in cartoons that defined the DC Universe for the Gen X crowd.

Or do we love her simply because she stands for a woman who defines herself: leaving home to explore the mysterious world beyond, choosing love with someone her mother didn't approve of, and forging a career on her own terms with unequalled courage? Other Super Heroes were fighting bank robbers, costumed clowns, or mad scientists — Wonder Woman would take on the God of War.

She was the woman who was the equal of anyone, mortal man or Greek god, our Wonder Woman.

— *Paul Levitz*

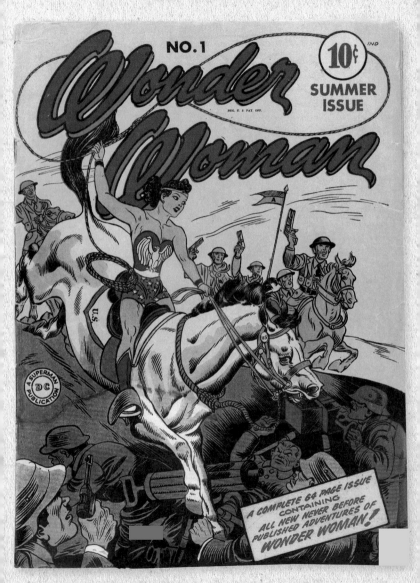

WARUM LIEBEN WIR
WONDER WOMAN?

Kommt es daher, dass sie sicher ist, dass wir sie lieben? Eine Frau, die absolutes Selbstvertrauen ausstrahlt, hat etwas Faszinierendes – und an Selbstvertrauen hat es der Amazonenprinzessin wahrlich nie gemangelt. Diejenigen, die sie zur Welt brachten, wollten es so. Damit ist nicht ihre Mutter, Königin Hippolyta, gemeint, sondern William Moulton Marston. Der war ein vielseitig gebildeter Mann, sowohl Jurist als auch Psychologe. Er hatte Romane und Ratgeber verfasst und für Zeitschriften geschrieben. Marstons Artikel über die wachsende Bedeutung der Comics führte dazu, dass DC ihm eine Stelle im verlagsinternen Beirat anbot – einem Ausschuss, der der Kritik entgegentreten sollte, Comics seien schlecht für Kinder. Außerdem sollte er auch selbst Comics schreiben. Ausgehend von seinen Interessen für Mythologie, Soziologie und speziell die gesellschaftliche Stellung der Frau, konzipierte Marston eine Abenteuerserie, in der er seine Theorien von Vorherrschaft und Unterwerfung zwischen den Geschlechtern vertrat. H. G. Peter, ein damals 61-jähriger Zeichner, der bereits für *Judge* gearbeitet hatte – eine Zeitschrift aus dem späten 19. und frühen 20. Jahrhundert mit eindringlichen politischen Karikaturen –, sorgte auch bei den Bildern für ein besonderes Niveau. Während Marston ab dem ersten Auftritt von Wonder Woman Ende 1941 bis zu seinem Tod sechs Jahre später sämtliche Texte schrieb oder beaufsichtigte, zeichnete Peter die Serie fast zwei Jahrzehnte lang.

Ihren ersten Auftritt hatte Wonder Woman in *All-Star Comics* 8, unmittelbar danach wurde sie der Star der neuen Anthologie *Sensation Comics*. Ihre eigene, vierteljährlich erscheinende Reihe kam wenig später – durch sie wurde die Heldin sofort zur Ikone.

Währenddessen diskutierten DCs Beirat und Psychologen, welche Wirkung Wonder Woman wohl auf Kinder habe – aus denen sich, so nahm man damals an, die Leserschaft aller Comics rekrutierte.

Wie jede stilvolle Frau verfügte auch Wonder Woman über die nötigen Accessoires. Dazu gehörten ein Lasso der Wahrheit (das Marstons wissenschaftliches Interesse an Lügendetektoren spiegelte), ein unsichtbares Flugzeug, ein Mentales Radio und Armreifen, an denen jede Kugel abprallte. Und eine Tiara. Wie cool war *das* denn?

Kommt es daher, dass sie genau zur rechten Zeit erschien? Wonder Woman debütierte im Oktober 1941. Das war kurz vor Amerikas Eintritt in den Zweiten Weltkrieg, als man die Männer bereits von ihrem Arbeitsplatz wegholte und zur militärischen Grundausbildung einzog. Als man ihre ersten Abenteuer las, drangen Frauen in ganz neue Berufszweige ein, um die dort fehlenden Männer zu ersetzen. Auch wenn DC so dumm war, Wonder Woman nur zur Sekretärin der Justice Society zu machen, so gehörte sie dennoch zum allerersten Superheldenteam und war den männlichen Kollegen mehr als ebenbürtig.

Wonder Woman war in den 1940er-Jahren so erfolgreich, dass sie zu einer der drei Superheldenfiguren wurde, die den Kollaps des Genres nach dem Krieg überlebten. Ihre Serie überdauerte die 1950er-Jahre, bis das Silberne Zeitalter der Comics die Superhelden zurückbrachte.

Eine Generation später bewies sie erneut perfektes Timing. Lynda Carter verkörperte Wonder Woman in einer Fernsehserie, deren Inhalte sich mehrfach änderten: von Weltkriegsabenteuern bis zu Geschichten, die in der Gegenwart spielten. Dennoch schaffte es die Reihe, den Idealen ihrer Protagonistin treu zu bleiben. Carter nahm ihre Rolle als Wonder Woman ernst und widerstand der Versuchung, sie ins Lächerliche zu ziehen. „Ich spielte lustige Stellen sehr menschlich, mit einer Art trockenem Humor", erklärte sie. „Ich wollte sie wie eine gewöhnliche Frau spielen, die zufällig Superkräfte besaß."

Kommt es daher, dass sie so coole Freunde hat? Der größte Fan von Wonder Woman, die Frauenrechtlerin Gloria Steinem, machte sie zum Titelmotiv des ersten *Ms. Magazine*. Und die Fernsehserie trug weiter dazu bei, dass die Amazonenprinzessin ein Aushängeschild der Frauenbewegung wurde. Zudem entwickelte sie sich zu einem der wichtigsten Mitglieder der *Super Friends*. In dieser Trickserie, die das DC-Universum den Kindern der 1970er- und 1980er-Jahre bekannt machte, kämpfte sie auf Augenhöhe neben Superman und Batman.

Oder lieben wir sie einfach, weil sie eine Frau verkörpert, die ihren Weg geht? Eine Frau, die ihre Heimat verlässt, um eine ihr fremde Welt zu erkunden. Die eine Beziehung wählt, die ihre Mutter nicht gutheißt. Die sich ihr eigenes Leben aufbaut und dabei außergewöhnlichen Mut beweist. Andere Superhelden kämpften gegen Bankräuber, kostümierte Clowns oder verrückte Wissenschaftler – Wonder Woman gegen den Kriegsgott.

Seien es nun Sterbliche oder griechische Götter – unsere Wonder Woman war die Frau, die es mit jedem aufnehmen konnte.

— *Paul Levitz*

WONDER WOMAN No. 1
Page 10: *Cover art, H. G. Peter, summer 1942.*

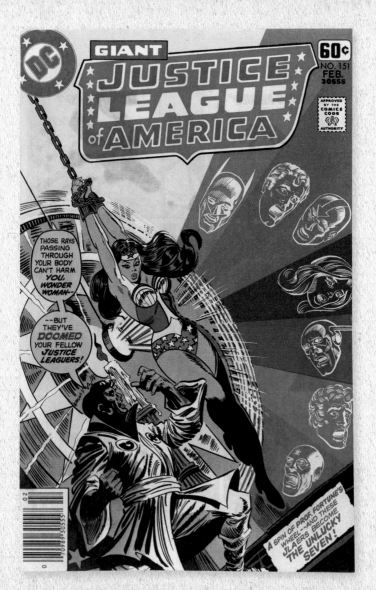

POURQUOI AIMONS-NOUS WONDER WOMAN ?

Est-ce parce qu'elle semble si sûre de l'effet qu'elle nous fait ? Il se dégage de certaines femmes une confiance absolue, rayonnante, dont la princesse amazone irradie. C'est ainsi que son créateur l'a voulue. Non pas la reine Hippolyte en personne, mais William Moulton Marston. Homme de culture, formé au droit et à la psychologie, il fut aussi romancier, auteur de livres de développement personnel et rédacteur pour la presse magazine. L'article que Marston consacra à la montée en puissance des comics lui valut une invitation à siéger au conseil consultatif de DC Comics (un groupe de sommités constitué pour déjouer les critiques selon lesquelles les comics seraient mauvais pour les enfants), mais aussi à écrire pour l'entreprise. Marston combina son goût pour la mythologie, la sociologie et les femmes et commença à rédiger une série d'aventures où s'illustraient ses théories sur la domination et la soumission en tant que rôles sociaux. H.G. Peter, un dessinateur de 61 ans dont les racines artistiques remontaient à *Judge*, un célèbre magazine satirique (publié de 1881 à 1947) rempli de caricatures et bandes dessinées politiques à l'acide, apporta au projet une sensibilité unique. Depuis sa première apparition fin 1941, Marston écrivit ou supervisa tous les scripts de Wonder Woman, jusqu'à sa mort six ans plus tard. Peter, en revanche, continua à dessiner la série pendant encore presque vingt ans.

Wonder Woman entra en scène dans *All-Star Comics* nº 8, et devint immédiatement la vedette d'une nouvelle anthologie, *Sensation Comics*, puis d'un magazine trimestriel dédié. Elle jouit instantanément du statut d'icône, et déclencha tout aussi brutalement, notamment au sein du conseil consultatif et parmi les psys, un débat houleux à propos de l'effet qu'elle aurait sur les enfants… le supposé

lectorat de tout comic à l'époque. Elle arborait aussi des accessoires parfaits, comme toute femme ayant du style : son lasso de la vérité (qui fait écho à l'intérêt de Marston pour les détecteurs de mensonges, qu'il participa à populariser), son avion invisible, sa radio mentale, ses bracelets mitrailleurs… et sa tiare. Qu'est-ce qu'il y avait de plus cool que ça ?

Est-ce parce qu'elle arrive toujours au bon moment ? L'Amérique rencontra Wonder Woman en octobre 1941, juste avant l'entrée du pays dans la Seconde Guerre mondiale, alors que la conscription arrachait des milliers d'hommes à leur travail pour qu'ils se forment au combat. Tandis qu'elle inspirait le pays entier avec ses aventures, les femmes progressaient dans des secteurs du monde du travail qui leur étaient jusqu'alors fermés, pour remplacer les hommes enrôlés. C'était l'époque de Rosie la Riveteuse, et si DC Comics feint la bêtise de la cantonner au rôle de secrétaire pour la Justice Society, elle n'en demeure pas moins membre du premier groupe de superhéros, dont elle est largement digne.

Sa carrière fut émaillée de tant de succès dès les années 1940 qu'elle est un des trois superhéros qui survécut à l'effondrement du genre, au lendemain de la guerre, et conserva un titre dédié de façon continue, jusqu'à ce que l'Âge d'argent des comics leur donne un second souffle.

Une génération plus tard, elle tombe encore à pic. Lynda Carter incarne Wonder Woman dans un feuilleton télévisé qui cherche un temps ses marques, passant de la Seconde Guerre mondiale à l'époque contemporaine, mais ne s'éloigne jamais des idéaux que le personnage représente. Carter prend son rôle de Wonder Woman très au sérieux, et résiste à la tentation, facile, d'une approche caricaturale. « Je jouais l'humour d'une façon très humaine, plutôt sèche en fait, » expliquait-elle. « J'ai essayé de jouer une femme normale, qui se trouve avoir des pouvoirs surhumains. »

Est-ce parce qu'elle traîne avec les gars les plus cools ? La plus grande fan de Wonder Woman, Gloria Steinem, lui offre la première Une de *Ms. Magazine* et le feuilleton lie plus encore le personnage de

la princesse amazone au mouvement d'émancipation des femmes, dont elle devient une icône. Comme si tout cela ne suffisait pas, elle est aussi un des éléments clé de *Super Friends*, jouant d'égal à égal avec Superman et Batman dans des dessins qui ont défini l'univers DC aux yeux de la génération X.

Ou peut-être l'aimons-nous simplement parce qu'elle est une femme qui choisit sa destinée : quitter son foyer pour explorer un monde mystérieux, défendre un amour que sa mère désapprouve et se forger une carrière selon ses propres lois, avec un courage sans égal ? Les autres superhéros combattaient des braqueurs de banque, des clowns costumés ou des savants fous – Wonder Woman, elle, s'attaquait au Dieu de la Guerre.

Elle était la femme qui était l'égale de tous, mortel ou dieu grec, notre Wonder Woman.

— Paul Levitz

JUSTICE LEAGUE OF AMERICA No. 151
Page 14: *Cover art, Al Milgrom and Joe Orlando, February 1978.*

THE GOLDEN AGE
1941–1956

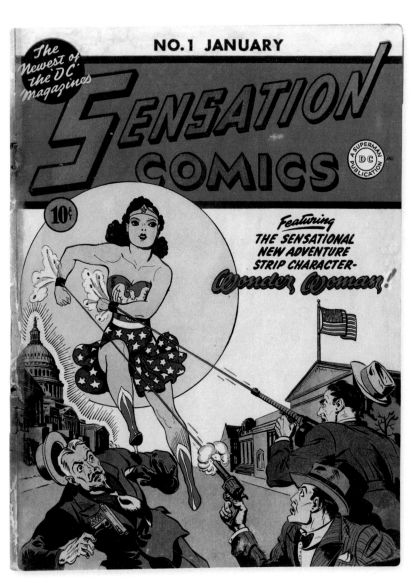

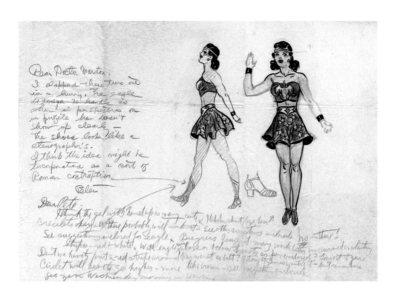

WONDER WOMAN No. 21

Previous spread: *Cover art, H. G. Peter, January – February 1947.*

SENSATION COMICS No. 1

Opposite: *Cover art, H. G. Peter (Wonder Woman) and Jon L. Blummer (villains and background), January 1942.* Flashing her iconic bullet-deflecting bracelets, Wonder Woman leaped into her own series, headlining All-American's latest monthly.

FIRST WONDER WOMAN SKETCHES

Above: *Concept art by H. G. Peter with notes from William Moulton Marston, ca. 1941.* H. G. Peter's preliminary drawings of Wonder Woman were carefully scrutinized by Marston in his notes, but the costume appeared in comic books largely as it appeared here. The two notable differences were the covering of her bare midriff with a girdle and her footwear, which became red boots in the published account. Shortly after Marston's death in 1948, Wonder Woman began wearing sandals with straps running up her calf. Intermittent at first, the change was consistent by 1950.

SENSATION COMICS No. 1

Below: *Interior, "Wonder Woman"; script, William Moulton Marston; pencils and inks, H.G. Peter. January 1942.*

WONDER WOMAN No. 12

Opposite: *Interior, "The Conquest of Venus"; script, Joye Murchison; pencils and inks, H.G. Peter. Spring 1945.* Triumphing by turning two "masculine" weapons against each other is a quintessential example of Wonder Woman's paradoxical mission to "Man's World": to rid it of the violence spawned by males, but often using that very same violence in the process.

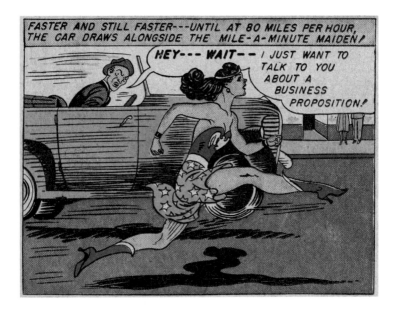

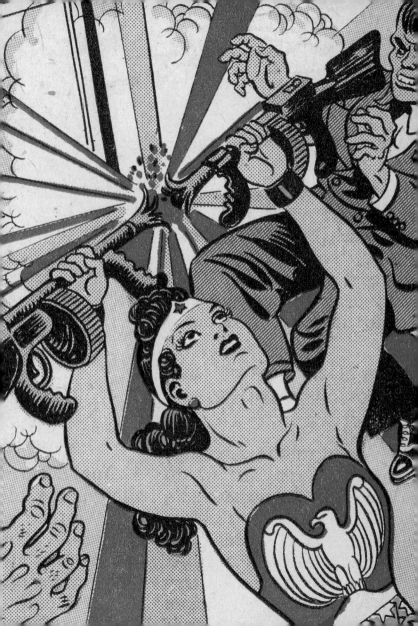

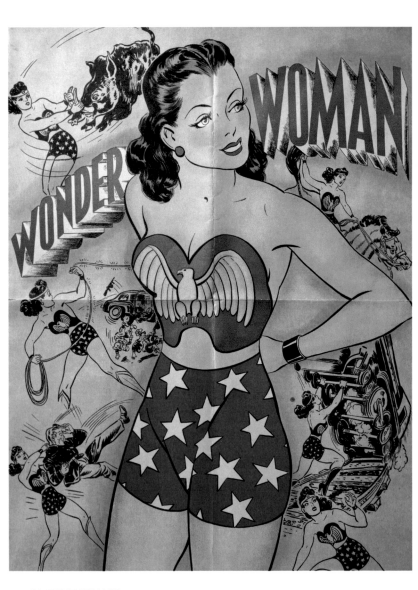

"WONDER WOMAN" NEWSPAPER
COMIC STRIP BROCHURE

Opposite: *Cover art, artist unknown, 1944*. A "Wonder Woman" newspaper strip was introduced with great fanfare in 1944 but failed to build much of a subscriber list and was canceled within a year.

WONDER WOMAN No. 75

Above: *Preliminary sketches, H.G. Peter, 1955.*

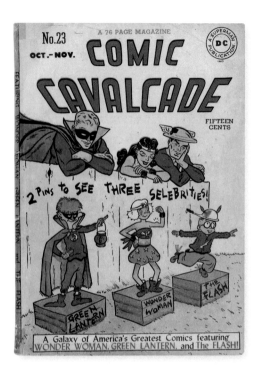

COMIC CAVALCADE No. 23

Above: *Cover art, Alex Toth (adult figures) and Harry Lampert (children and fence), October–November 1947.* The wish fulfillment inherent in Super Heroes is clearly on display here. The girl playing Wonder Woman is Cotton-Top Katie, the star of a kids humor feature seen in *Comic Cavalcade, All-American Comics,* and other titles.

THE BIG ALL-AMERICAN COMIC BOOK No. 1

Opposite: *Cover art, various artists, 1944.* All-American's first attempt at an omnibus, at 132 pages of original content, featured most of its heroes, as well as some humor features. It is considered among the rarest of AA publications, priced on the collector's market at more than $15,000.

COMIC CAVALCADE No. 1

Following spread: *Cover art, Frank Harry, winter 1942–1943.*

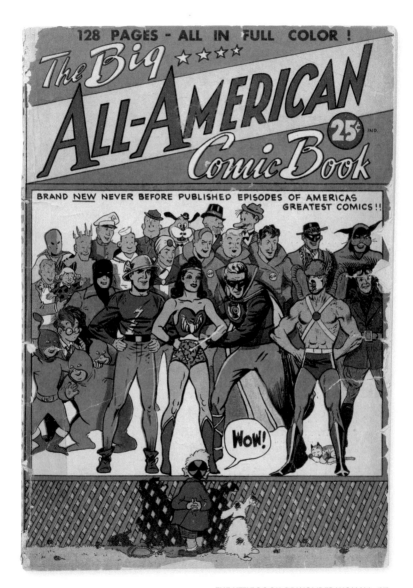

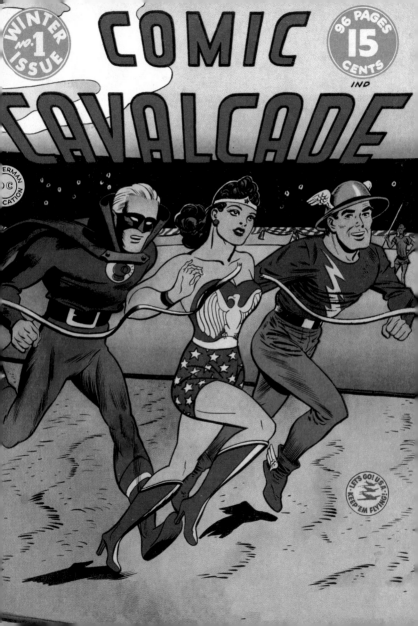

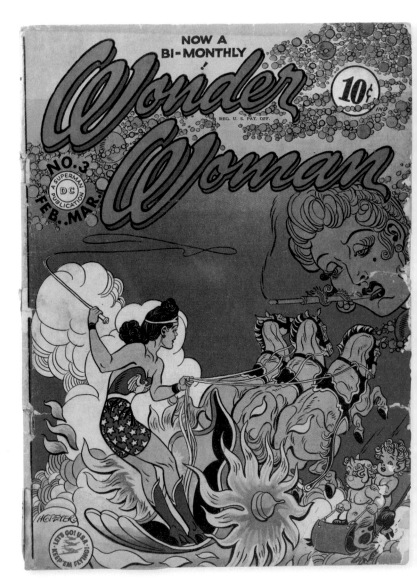

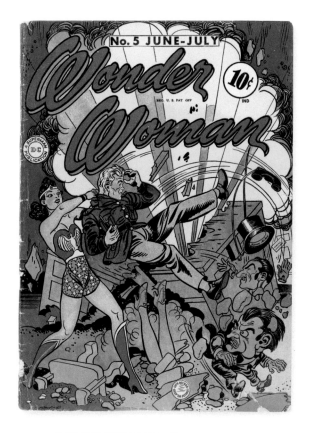

WONDER WOMAN No. 3

Opposite: *Cover art, H. G. Peter, February–March 1943.*

WONDER WOMAN No. 5

Above: *Cover art, H. G. Peter, June–July 1943.* Colonel Steve
Trevor was characterized by later generations as a "male
Lois Lane" whose only functions seemed to be chasing after
and being rescued by Wonder Woman. Under series creator
William Moulton Marston, the soldier was far more of an
equal partner. After Marston's death, Trevor became more
of a frustrated lover, engaging in a futile campaign to
convince Wonder Woman to marry him.

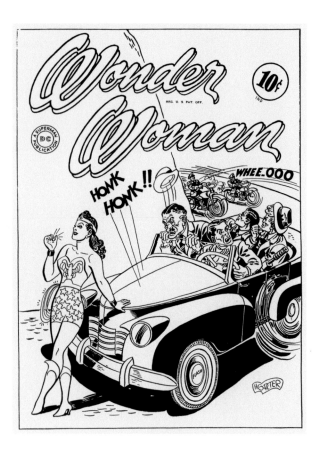

WONDER WOMAN UNPUBLISHED COVER

Above: *Original art, H.G. Peter, ca. 1945.* Wonder Woman's
ability to speed past cars was established from the moment
she arrived in the United States. After outracing a theatrical
promoter, she agreed to go on tour with her "Bullets and
Bracelets" act to earn money before acquiring her Diana
Prince alter ego.

SENSATION COMICS No. 28

Opposite: *Cover art, H.G. Peter, April 1944.*

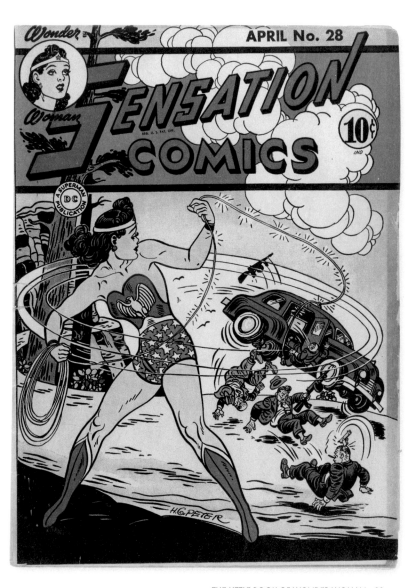

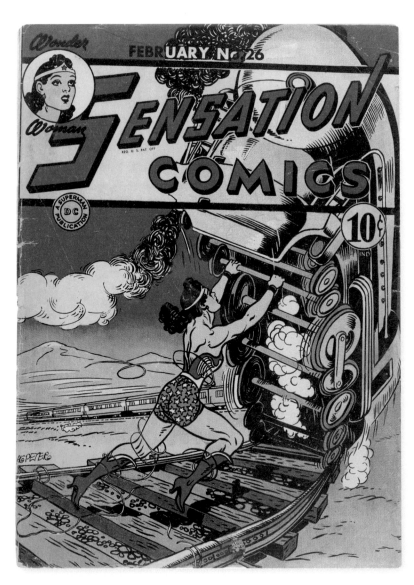

SENSATION COMICS No. 26

Opposite: *Cover art, H.G. Peter, February 1944.*

SENSATION COMICS No. 35

Below: *Cover art, H.G. Peter, November 1944.* Wonder Woman had several adventures in two rival kingdoms of Atlantis, one ruled by the benevolent Queen Eeras and the other by wicked Queen Clea.

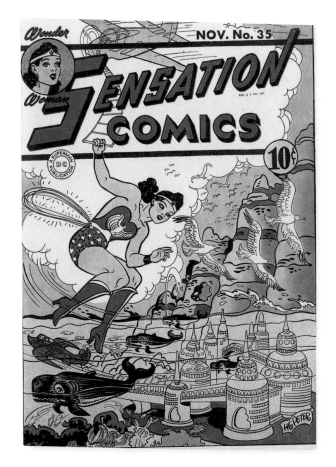

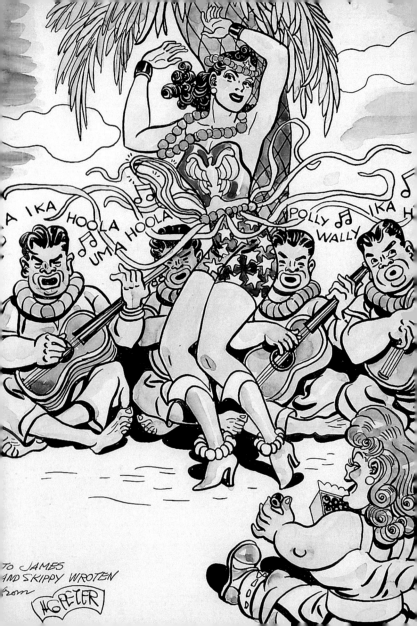

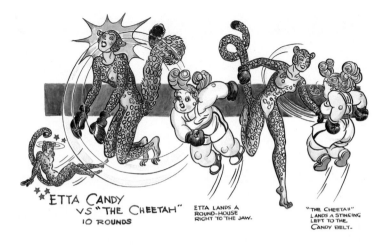

ETTA CANDY
vs "THE CHEETAH"
10 ROUNDS

ETTA LANDS A
ROUND-HOUSE
RIGHT TO THE JAW.

"THE CHEETAH"
LANDS A STINGING
LEFT TO THE
CANDY BELT-

WONDER WOMAN HULA

Opposite: *Unpublished illustration, H. G. Peter, 1940s.* Enjoying
Wonder Woman's hula dance is her comic sidekick, Etta
Candy. A mainstay of the series almost from the beginning,
the redheaded college student never backed down from a
challenge or rejected a box of chocolates. Within a few years
of Marston's death, sorority sisters Etta and the Holliday Girls
were quietly dropped.

ETTA CANDY VS. THE CHEETAH

Above: *Unpublished illustration, H. G. Peter, ca. 1940s.* The
schizophrenic Cheetah, who struggled with her more benign
persona of Priscilla Rich, was a favored villainess of the
Wonder Woman creators.

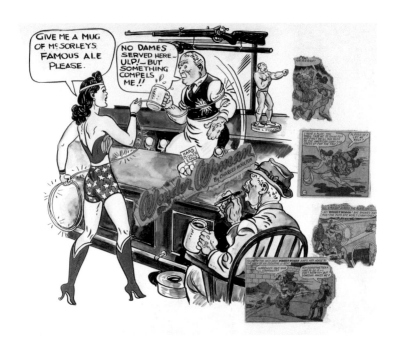

MCSORLEY'S FAMOUS ALE

Above: *Personalized art, H.G. Peter, ca. 1940s.* H.G. Peter occasionally drew personalized pieces like this one, set at McSorley's Old Ale House, New York City's oldest Irish tavern.

WONDER WOMAN CHRISTMAS CARD

Opposite: *Christmas card art, H.G. Peter, 1943.*

Wonder Woman
WISHES YOU
Holiday
Fun!

COMIC CAVALCADE

To

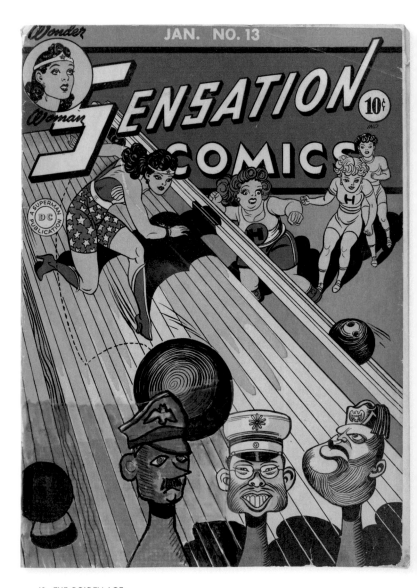

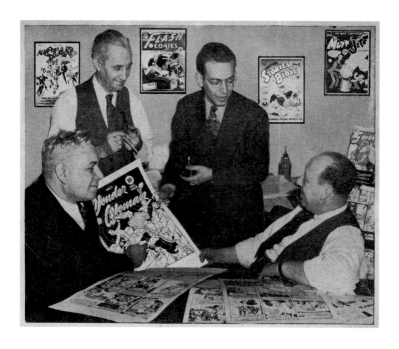

SENSATION COMICS No. 13

Opposite: *Cover art, H.G. Peter, January 1943.*

WONDER WOMAN CREATIVE TEAM

Above: *Photograph, left to right, William Moulton Marston, H.G. Peter, Sheldon Mayer, M.C. Gaines, 1942.* "Here they are in Mr. Gaines's office discussing this second issue of *Wonder Woman* on a warm day in August. But I almost had to get Wonder Woman and her magic lasso to get them to pose…"
— Alice Marble

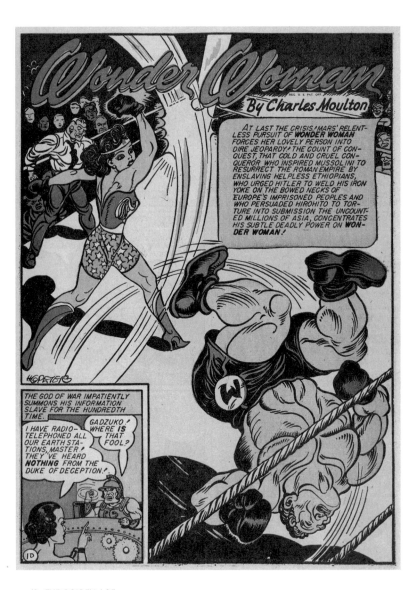

WONDER WOMAN No. 2

Opposite: *Interior, "Wonder Woman"; script, William Moulton Marston; pencils and inks, H.G. Peter. Fall 1942.* Part of Wonder Woman's appeal was the pure physicality of the character. Whether fighting the eight-foot-tall Mammotha or Mars, God of War, the Amazing Amazon struck down every obstacle in her path and empowered girls with the message that no challenge was insurmountable.

WONDER WOMAN No. 28

Above: *Cover art, H.G. Peter, April–May 1948.*

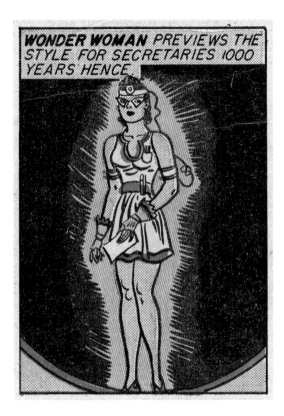

WONDER WOMAN No. 7

Above and opposite: *Cover art, H.G. Peter. Interior, "The Adventure of the Life Vitamin": script, William Moulton Marston; pencils and inks, H.G. Peter. Winter 1943.* William Moulton Marston's vision for the future was never more clear than in a full-length story depicting events in the 31st century and beyond. Beyond technological advances like a headband that transcribes thoughts into print, society becomes a utopia free of war and disease, and Diana (Wonder Woman) Prince becomes president of the United States—but only after apologetically resigning as secretary to the male General Darnell. "Men and women will be equal," the text asserts, "but women's influence will control most governments because women are more ready to serve others unselfishly."

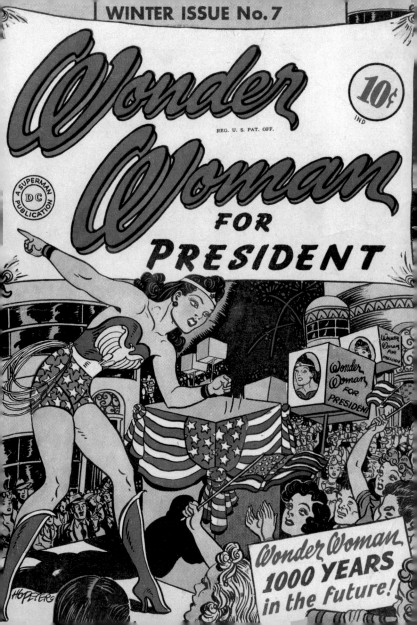

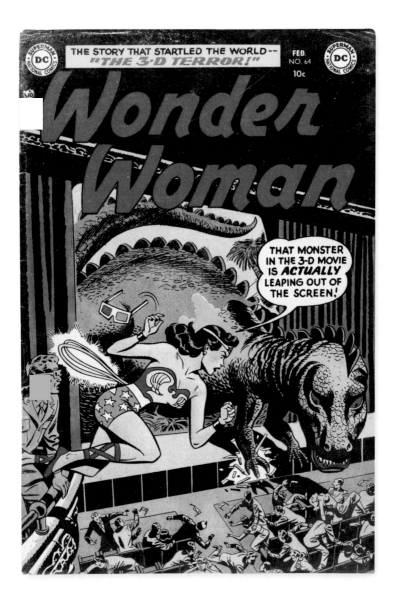

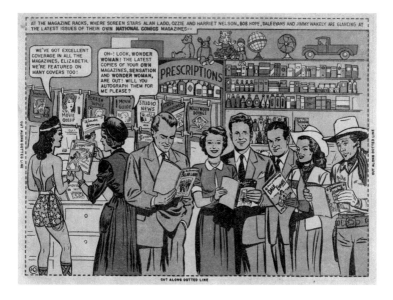

WONDER WOMAN No. 64

Opposite: *Cover art, Irwin Hasen, February 1954.* In a typically bizarre plot, would-be invaders from Jupiter began transmitting creatures through 3-D filmstrips to determine if they could safely do the same. Wonder Woman stopped them by arranging for them to make their transfer on "a 3-D film of the most powerful hydrogen explosion we ever had," thus causing the Jovians to blow themselves up.

WONDER WOMAN No. 40

Above: *Interior, "Hollywood Goes to Paradise Island"; script, Robert Kanigher; pencils and inks, H. G. Peter and Win Mortimer (foreground celebrities only). March – April 1950.* In Hollywood to participate in a movie about her own adventures, Wonder Woman takes time to pose in a pinup featuring every screen performer then appearing in a DC comic book: Alan Ladd, Ozzie and Harriet Nelson, Bob Hope, Dale Evans, and Jimmy Wakely. A year before this story, Ladd crossed paths with Miss Beverly Hills of Hollywood in the first issue of her comic book, and Dale Evans co-starred with the Boy Commandos in No. 32 of their own title.

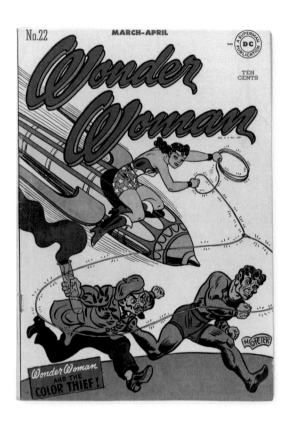

WONDER WOMAN No. 22

Above: *Cover art, H. G. Peter, March–April 1947.*

WONDER WOMAN No. 16

Opposite: *Interior, "The Secret of the Dark Planet"; script, Joye Murchison; pencils and inks, H. G. Peter. March–April 1946.* Almost from the start, Wonder Woman brought her message of peace and equality to the people of other planets. She formed a close relationship with Queen Desira and the women of Venus, fought the war god Mars on the planet that bore his name, and even helped set diplomatic relations between Saturn and Earth. Sometimes those adventures came at the instigation of Wonder Woman's friend Etta Candy, who travels to the planet Pluto to rescue a classmate.

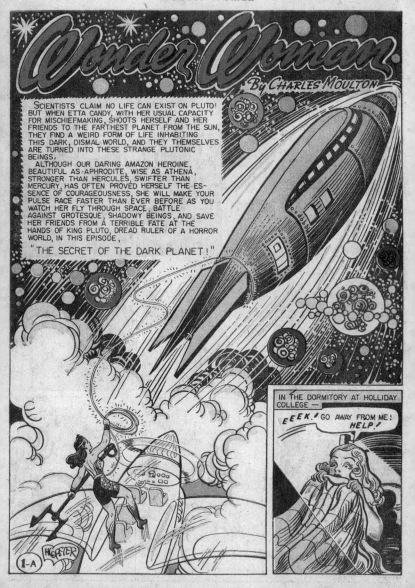

Wonder Woman

By CHARLES MOULTON

SCIENTISTS CLAIM NO LIFE CAN EXIST ON PLUTO! BUT WHEN ETTA CANDY, WITH HER USUAL CAPACITY FOR MISCHIEFMAKING, SHOOTS HERSELF AND HER FRIENDS TO THE FARTHEST PLANET FROM THE SUN, THEY FIND A WEIRD FORM OF LIFE INHABITING THIS DARK, DISMAL WORLD, AND THEY THEMSELVES ARE TURNED INTO THESE STRANGE PLUTONIC BEINGS.

ALTHOUGH OUR DARING AMAZON HEROINE, BEAUTIFUL AS APHRODITE, WISE AS ATHENA, STRONGER THAN HERCULES, SWIFTER THAN MERCURY, HAS OFTEN PROVED HERSELF THE ESSENCE OF COURAGEOUSNESS, SHE WILL MAKE YOUR PULSE RACE FASTER THAN EVER BEFORE AS YOU WATCH HER FLY THROUGH SPACE, BATTLE AGAINST GROTESQUE, SHADOWY BEINGS, AND SAVE HER FRIENDS FROM A TERRIBLE FATE AT THE HANDS OF KING PLUTO, DREAD RULER OF A HORROR WORLD, IN THIS EPISODE,

"THE SECRET OF THE DARK PLANET!"

IN THE DORMITORY AT HOLLIDAY COLLEGE —

EEEK! GO AWAY FROM ME! HELP!

1-A

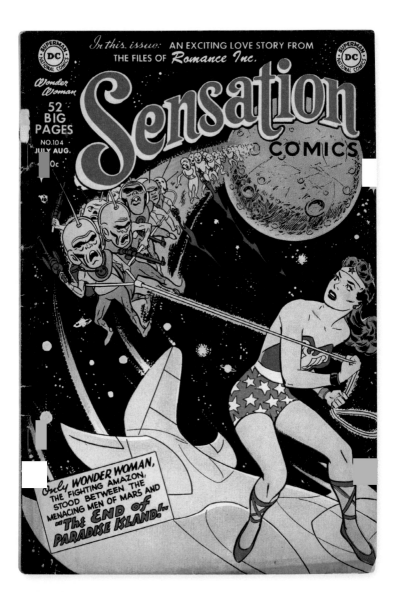

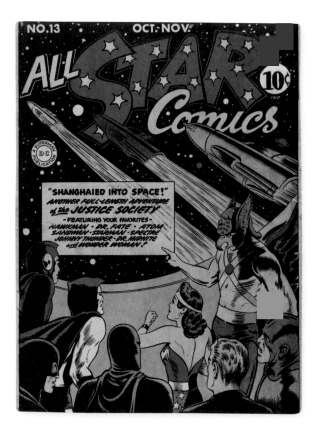

SENSATION COMICS No. 104

Opposite: *Cover art, Irwin Hasen and Bernard Sachs, July – August 1951.* Wonder Woman seemed to have a particular problem with invaders from Mars, a planet that was home to her nemesis the Duke of Deception.

ALL-STAR COMICS No. 13

Above: *Cover art, Jack Burnley, October – November 1942.* Demonstrating a degree of technology that Nazi Germany could only dream of in the real world, Adolf Hitler attempted to get rid of the Justice Society by rocketing each member of the team to a different planet in the solar system.

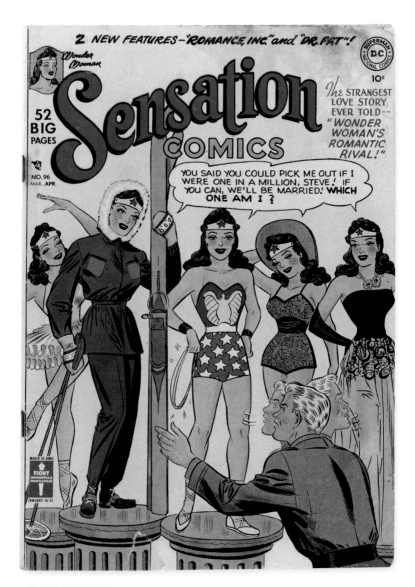

SENSATION COMICS No. 96

Opposite: *Cover art, Irwin Hasen, March–April 1950.*

SENSATION COMICS No. 97

Below: *Cover art, Irwin Hasen, May–June 1950.* When romance comics boomed for other publishers, *Sensation Comics* switched to that format in the hope of saving the title from cancellation. In addition to Wonder Woman's new job writing a newspaper advice column for young lovers, the comic book also featured series starring small-town female physician Dr. Pat and tales of Romance, Inc. with Ann Martin.

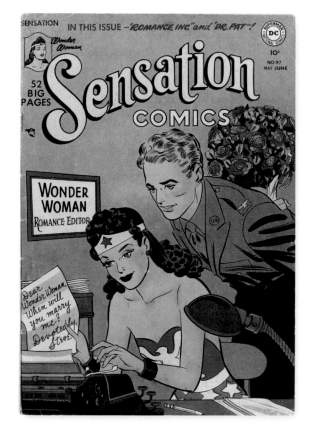

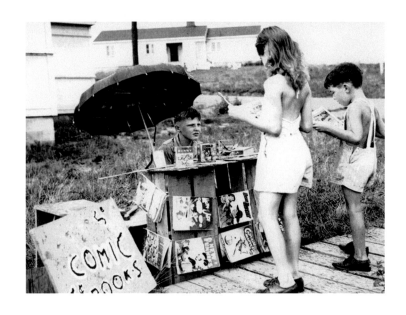

NICKEL COMICS STAND

Above: *Photograph, unknown, ca. 1942.*

WONDER WOMAN No. 23

Opposite: *Cover art, H. G. Peter. May – June 1947.* The notion
of Amazon home movies featuring Wonder Woman as a child
was revisited with a vengeance in the 1960s when the films
were spliced together to depict the heroine interacting with
her younger selves and mother as the Wonder Family.

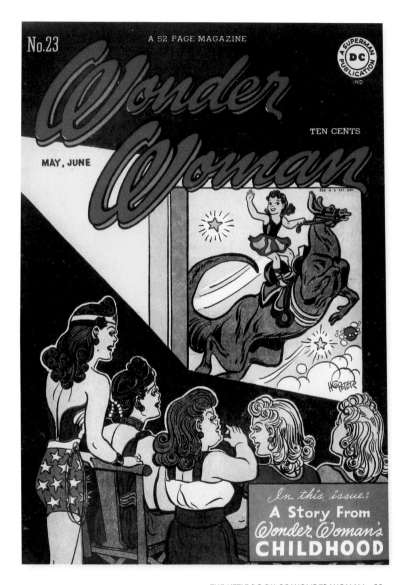

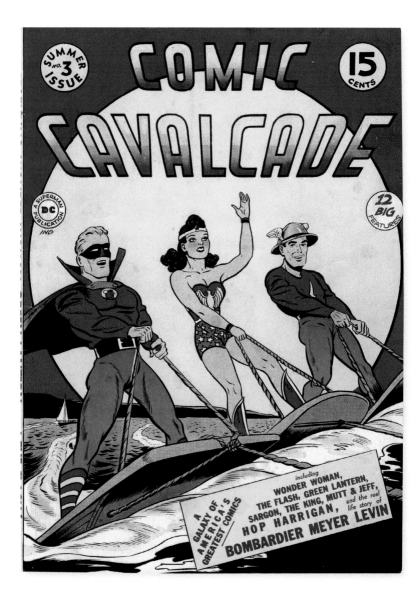

COMIC CAVALCADE No. 3

Opposite: *Cover art, Frank Harry, Summer 1943.*

ALL-STAR COMICS No. 46

Below: *Interior, "The Adventure of the Invisible Band"; script, John Broome; pencils, Irwin Hasen; inks, Bob Oksner. April–May 1949.* Even with the war behind them, the Justice Society still viewed buying bonds as a good investment. Citizens who purchased United States Savings Bonds eventually received dividends on money that was put to use in the meantime to finance government expenses.

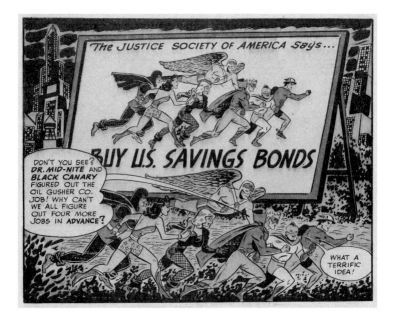

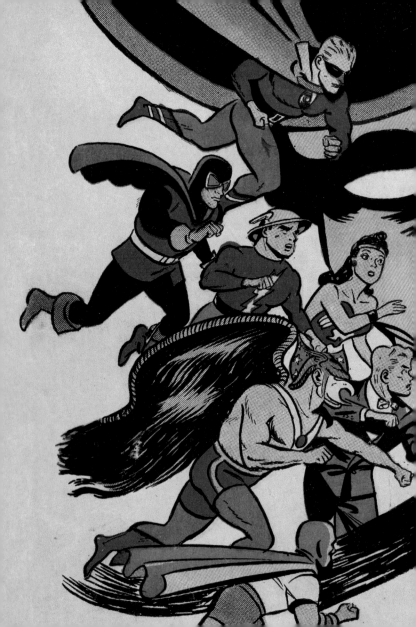

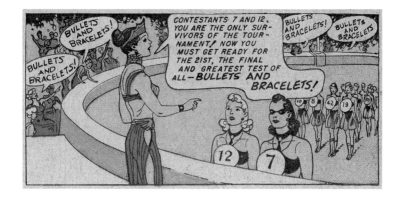

ALL-STAR COMICS No. 34

Previous spread: *Cover art, Irwin Hasen, April–May 1947.* The blank-eyed Wizard was one of the Justice Society's greatest foes, returning only three issues after his debut to attack them as part of the Injustice Society.

ALL-STAR COMICS No. 8

Above: *Interior, "Introducing Wonder Woman"; script, William Moulton Marston (as Charles Moulton); pencils and inks, H.G. Peter. December 1941–January 1942.* The extraordinary competition of Bullets and Bracelets requires contestants to move fast enough to deflect shells fired from a gun with their metal wristbands. The Amazons are obviously made of sterner stuff than mere mortals, and Wonder Woman uses the stunt to earn money when she first arrives in the United States.

ALL-STAR COMICS No. 16

Opposite: *Cover art, Frank Harry, April–May 1943.* The Justice Society may have received the spotlight, but the point of the cover and its accompanying story was that everyone in the United States was on the same team when it came to defeating the global threat of the Axis powers.

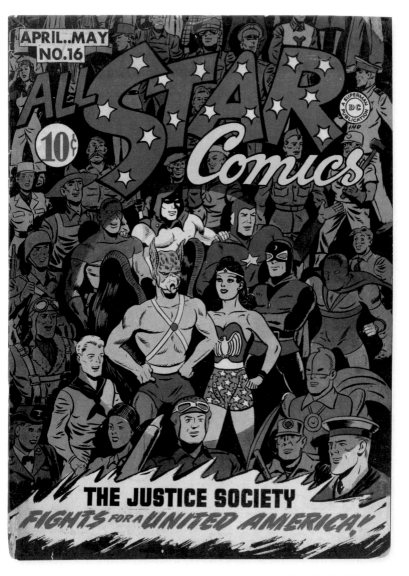

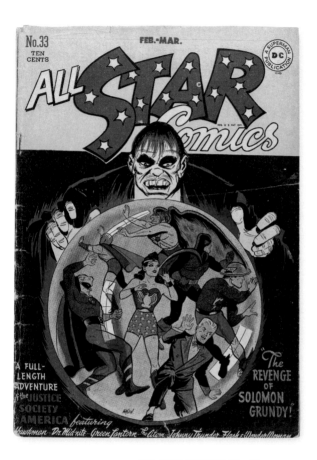

ALL-STAR COMICS No. 33

Above: *Cover art, Irwin Hasen, February–March 1947.*

ALL-STAR COMICS No. 14

Opposite: *Cover art, Joe Gallagher, December 1942–January 1943.*
Hunger is rampant in areas of war-ravaged Europe, leading
the Justice Society to provide a solution unavailable in the real
world. Making their way to the hardest-hit areas of the conti-
nent, they distribute capsules that expand into full-course
meals when treated with a special solution.

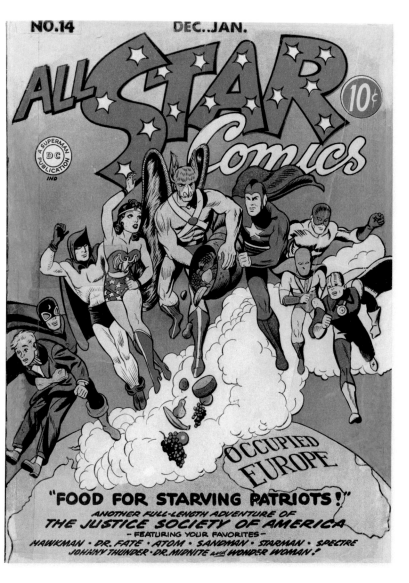

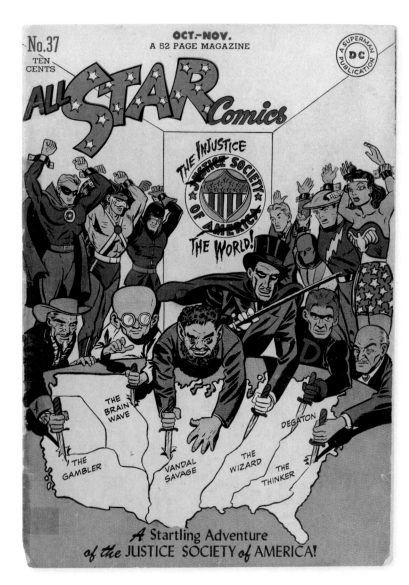

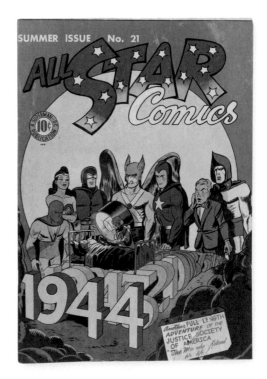

ALL-STAR COMICS No. 37

Opposite: *Cover art, Irwin Hasen, October–November 1947.*
The Injustice Society, composed of the captive heroes' indi-
vidual and collective foes, was not the first team of costumed
villains to pose a threat during the Golden Age, but it's
certainly one of the most memorable.

ALL-STAR COMICS No. 21

Above: *Cover art, Joe Gallagher, summer 1944.* A striking
composition suggests the passage of time as members of the
Justice Society travel back in time and change history on
behalf of a remorseful dying man. The team made other trips
forward and backward through time, but its most memorable
exploit in that regard may have been *All-Star Comics* No. 35's
"Day That Dropped out of Time," wherein the power-mad
Degaton altered the present by changing the distant past.

ALL-STAR COMICS No. 17

Below: *Cover art, Joe Gallagher, June–July 1943.*

ALL-STAR COMICS No. 50

Opposite: *Cover art, Arthur Peddy and Bob Oksner, December 1949–January 1950.* Near the end of its run, Green Lantern, Hawkman, Wonder Woman, and the Flash dominated the covers of *All-Star Comics* at the expense of lesser-known members of the Justice Society.

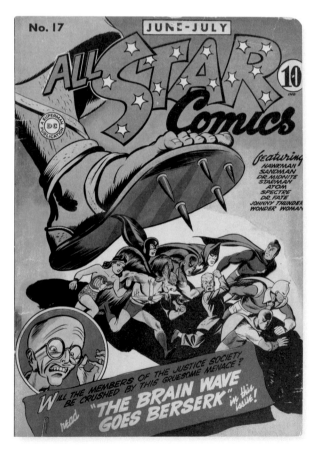

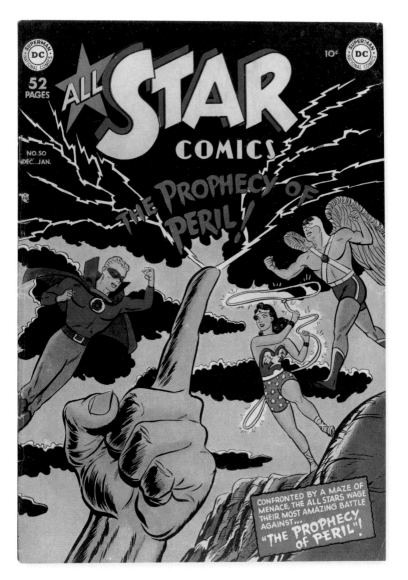

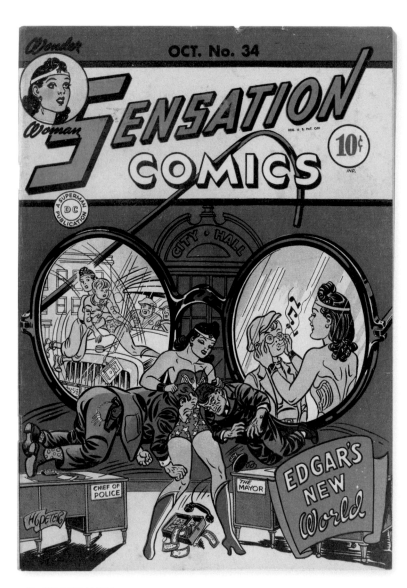

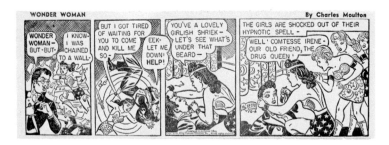

SENSATION COMICS No. 34

Opposite: *Cover art, H.G. Peter, October 1944.* Grand adventures
with invading armies and strange villains were balanced by
more intimate stories in which Wonder Woman improved the
lives of ordinary citizens. In "Edgar's New World," the kind-
hearted Amazon provides a vision-impaired youngster with
new glasses and discovers that his mother has been falsely
imprisoned for his father's murder. Moved by the heroine's
efforts to exonerate his mom, Edgar must break his glasses
to save Wonder Woman's life later in the story.

WONDER WOMAN NEWSPAPER STRIP

Above: *Newspaper comic strip; script, William Moulton Marston;
pencils and inks, H.G. Peter. October 1944.*

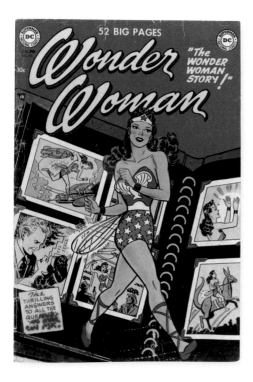

WONDER WOMAN No. 45

Above: *Cover art, Irv Novick and Bernard Sachs, January–February 1951*. The eye-catching design of this cover likely also includes the influence of editor Robert Kanigher. A writer with a strong sense of what would make an effective visual display, as well as an occasional painter, he conceived similar images for the cover and splash page of the first Silver Age Flash story in 1956's *Showcase* No. 4 as well as the cover of *Wonder Woman* No. 103.

WONDER WOMAN No. 53

Opposite: *Cover art, Irv Novick, May–June 1952*. Here Wonder Woman is questioned while attached to the device that her creator, William Moulton Marston, was instrumental in inventing. Indeed, Marston provided his heroine with her own portable lie detector—a magic golden lasso—in 1942's *Sensation Comics* No. 6.

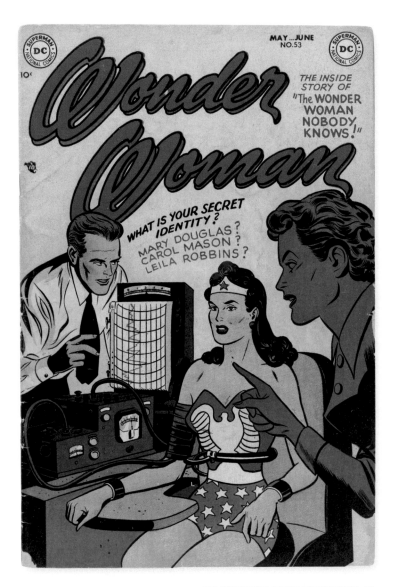

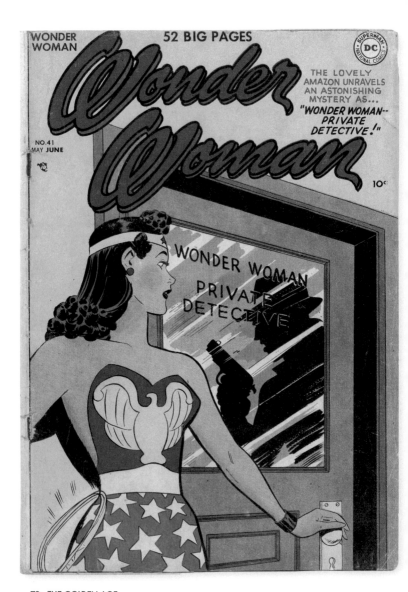

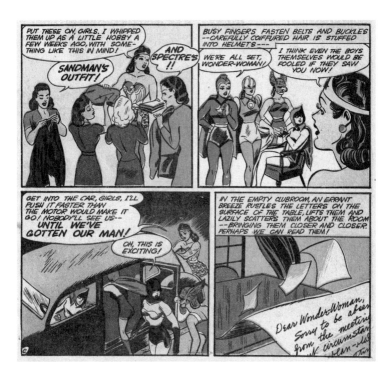

WONDER WOMAN No. 41

Opposite: *Cover art, Irwin Hasen and Bernard Sachs, May–June 1950.*
Although Diana Prince once established a detective agency in
pursuit of a criminal, her alter ego of Wonder Woman gained a
more long-lived occupation that same month in *Sensation Comics*:
romance editor of the *Daily Globe*.

ALL-STAR COMICS No. 15

Above: *Interior, "The Man Who Created Images"; script, Gardner
Fox; pencils and inks, Joe Gallagher. February–March 1943.*

THE SILVER AGE
1956–1970

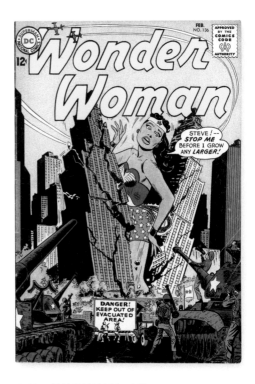

WONDER WOMAN No. 108

Previous spread: *Cover art, Ross Andru and Mike Esposito, August 1959.*

WONDER WOMAN No. 90

Opposite: *Cover art, Irv Novick, May 1957.*

WONDER WOMAN No. 136

Above: *Cover art, Ross Andru and Mike Esposito, February 1963.*
An alien weapon causes Wonder Woman to grow to colossal size—and then keep growing. At first, her ravenous appetite threatens world food supplies, and before long her massive weight generates seismic tremors that menace the very foundations of our greatest cities. This "tall tale" wrought its emotion from our heroine's anguish, and from Col. Steve Trevor's grief as he wrestles with orders to destroy the woman he loves.

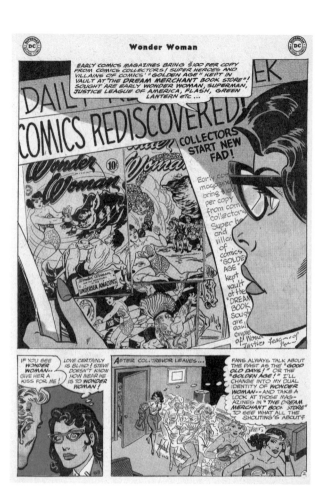

WONDER WOMAN No. 156

Above and opposite: *Interiors, "The Brain Pirate of the Inner World"; script, Robert Kanigher; pencils, Ross Andru; inks, Mike Esposito. August 1965.* Kanigher's was the first story to center on collectible Golden Age comics and those who buy and sell them. Like most adults, he considered anyone over the age of 12 who still read comics to be an oddball, and it showed.

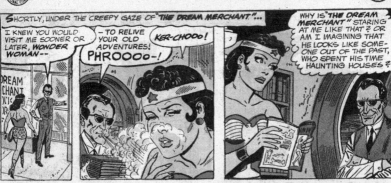

SHORTLY, UNDER THE CREEPY GAZE OF "THE DREAM MERCHANT"...

I KNEW YOU WOULD VISIT ME SOONER OR LATER, WONDER WOMAN--

--TO RELIVE YOUR OLD ADVENTURES!

KER-CHOOO! PHROOOO~!

WHY IS "THE DREAM MERCHANT" STARING AT ME LIKE THAT? OR AM I IMAGINING THAT HE LOOKS LIKE SOMEONE OUT OF THE PAST, WHO SPENT HIS TIME HAUNTING HOUSES?

DREAM CHANT

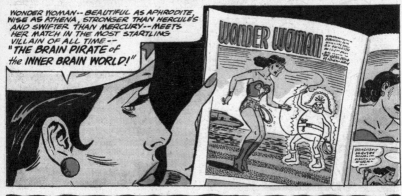

WONDER WOMAN-- BEAUTIFUL AS APHRODITE, WISE AS ATHENA, STRONGER THAN HERCULES AND SWIFTER THAN MERCURY--MEETS HER MATCH IN THE MOST STARTLING VILLAIN OF ALL TIME--
"THE BRAIN PIRATE of the INNER BRAIN WORLD!"

WONDER WOMAN

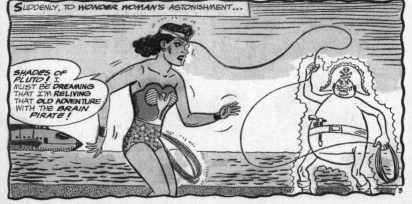

SUDDENLY, TO WONDER WOMAN'S ASTONISHMENT...

SHADES OF PLUTO! I MUST BE DREAMING THAT I'M RELIVING THAT OLD ADVENTURE WITH THE BRAIN PIRATE!

3

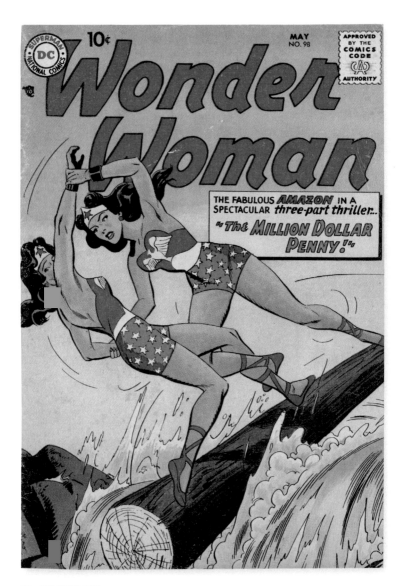

WONDER WOMAN No. 98

Opposite: *Cover art, Ross Andru and Mike Esposito, May 1958.*
Following the death of original series artist H.G. Peter, Robert
Kanigher assigned the lively Andru–Esposito art team to
refresh and modernize Wonder Woman.

JUSTICE LEAGUE OF AMERICA No. 73

Below: *Cover art, Joe Kubert, August 1969.* This dramatic
Joe Kubert cover was blunt, but a number of DC-sponsored
advocacy ads and in-story developments expressed sustained
recognition of every child's worth, if more politely than here.
Most notably, Superman proudly promoted the President's
Council on Physical Fitness in a tale shelved following JFK's
assassination until the Kennedy family specifically requested
DC run it in his honor.

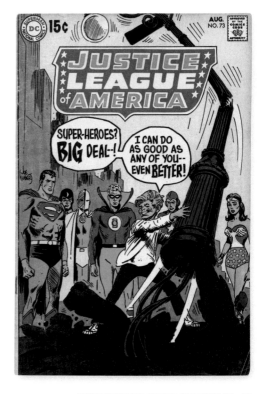

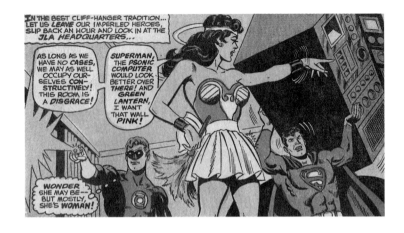

JUSTICE LEAGUE OF AMERICA No. 66

Above: *Interior, "Divided — They Fall"; script, Denny O'Neil; pencils, Mike Sekowsky; inks, Sid Greene. November 1968.* Lest readers forget the gender roles within the JLA, the point was driven home in this scene, where Wonder Woman plays over-bearing den mother to the men of the League.

JUSTICE LEAGUE OF AMERICA No. 5

Opposite: *Cover art, Mike Sekowsky and Bernard Sachs, June – July 1961.* Even though they were active members, by editorial edict, Superman and Batman were initially forbidden from appearing on *Justice League* covers (though if you look closely, you can make them out in the background here). Mort Weisinger and Jack Schiff were both wary of the *World's Finest* team being "overexposed." Eventually, either common sense or the publisher's mandate (or perhaps both) overruled their petulant proclamation.

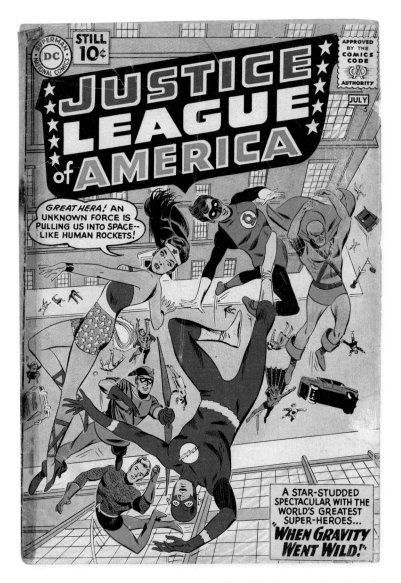

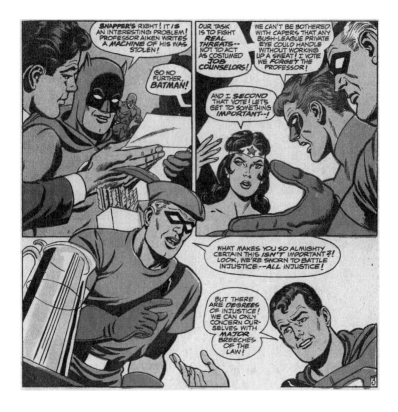

JUSTICE LEAGUE OF AMERICA No. 66

Above: *Interior, "Divided They Fall"; script, Denny O'Neil; pencils, Dick Dillin; inks, Sid Greene, November 1968.*

THE BRAVE AND THE BOLD No. 63

Opposite: *Interior, "The Revolt of the Super-Chicks"; script, Bob Haney; pencils and inks, John Rosenberger. December 1965– January 1966.* Sick of living in a "man's world," Supergirl and Wonder Woman abandon their heroic responsibilities and relocate to France to steep themselves in fashion and romance. Super-feminism rocks!

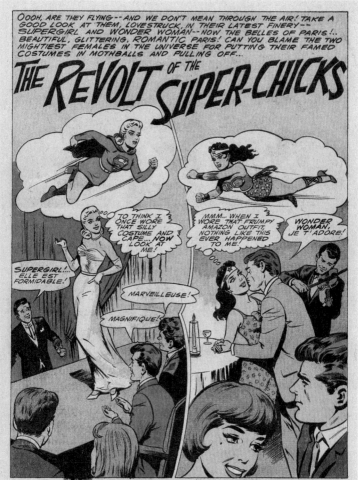

THE BRAVE AND THE BOLD, No. 63. Dec., 1965 - Jan., 1966. Published bi-monthly by NATIONAL PERIODICAL PUBLICATIONS, INC., Second and Dickey Streets, SPARTA, ILL. Editorial, Executive offices and subscriptions, 575 LEXINGTON AVENUE, NEW YORK 22, N.Y. George Kashdan, Editor. SECOND CLASS POSTAGE RATES PAID AT SPARTA, ILL. under the act of March 3, 1879. Yearly subscription in the U.S., 70¢ including postage. Foreign, $1.40 in American funds.

Canada, 85¢ in American funds. For advertising rates address Richard A. Feldon & Co., 205 East 42nd St., New York 17, N.Y. Copyright © National Periodical Publications, Inc., 1965. All rights reserved under International and Pan-American Copyright Conventions. The stories, characters and incidents mentioned in this magazine are entirely fictional. No actual persons, living or dead, are intended or should be inferred.

Printed in U.S.A.

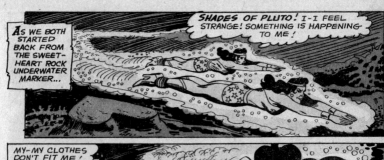

AS WE BOTH STARTED BACK FROM THE SWEET-HEART ROCK UNDERWATER MARKER...

SHADES OF PLUTO! I-I FEEL STRANGE! SOMETHING IS HAPPENING TO ME!

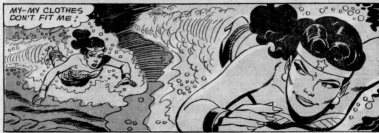

MY-MY CLOTHES DON'T FIT ME!

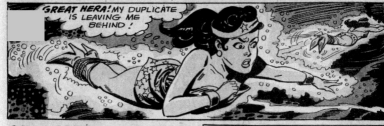

GREAT HERA! MY DUPLICATE IS LEAVING ME BEHIND!

SUDDENLY, I REALIZED WHAT HAD HAPPENED...

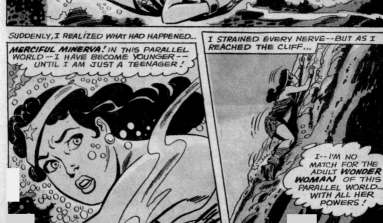

MERCIFUL MINERVA! IN THIS PARALLEL WORLD -- I HAVE BECOME YOUNGER -- UNTIL I AM JUST A TEENAGER!

I STRAINED EVERY NERVE--BUT AS I REACHED THE CLIFF...

I--I'M NO MATCH FOR THE ADULT WONDER WOMAN OF THIS PARALLEL WORLD... WITH ALL HER POWERS!

20

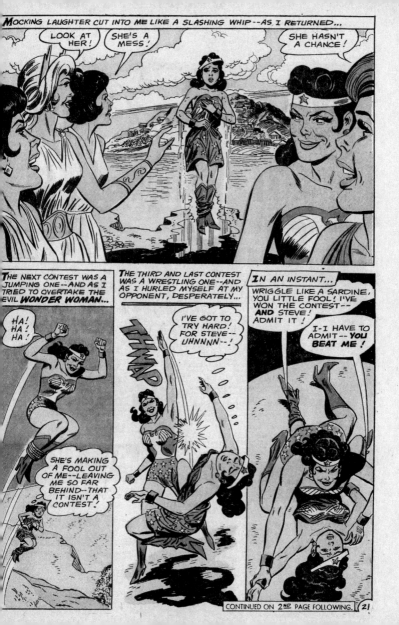

MOCKING LAUGHTER CUT INTO ME LIKE A SLASHING WHIP--AS I RETURNED...

LOOK AT HER!

SHE'S A MESS!

SHE HASN'T A CHANCE!

THE NEXT CONTEST WAS A JUMPING ONE--AND AS I TRIED TO OVERTAKE THE EVIL **WONDER WOMAN**...

HA! HA! HA!

SHE'S MAKING A FOOL OUT OF ME--LEAVING ME SO FAR BEHIND--THAT IT ISN'T A CONTEST!

THE THIRD AND LAST CONTEST WAS A WRESTLING ONE--AND AS I HURLED MYSELF AT MY OPPONENT, DESPERATELY...

I'VE GOT TO TRY HARD! FOR STEVE-- UHNNNNN--!

THWAP

IN AN INSTANT...

WRIGGLE LIKE A SARDINE, YOU LITTLE FOOL! I'VE WON THE CONTEST-- **AND** STEVE! ADMIT IT!

I-I HAVE TO ADMIT-- **YOU BEAT ME!**

CONTINUED ON 2ND PAGE FOLLOWING. 21

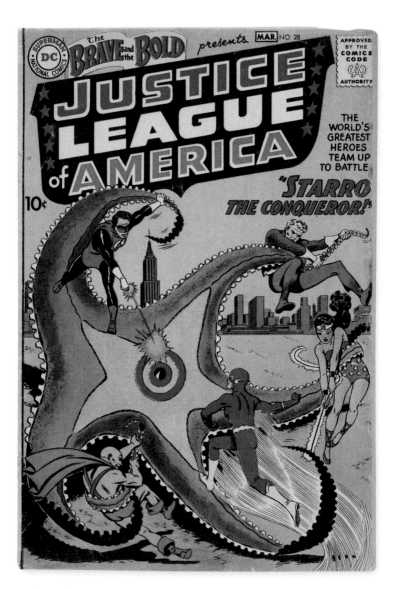

WONDER WOMAN No. 175

Previous spread: *Interior, "Wonder Woman's Evil Twin"; script, Robert Kanigher; pencils, Irv Novick; inks, Mike Esposito. March–April 1968.*

THE BRAVE AND THE BOLD No. 28

Opposite: *Cover art, Mike Sekowsky and Murphy Anderson, February–March 1960.*

JUSTICE LEAGUE OF AMERICA No. 16

Above: *Interior, "Cavern of Deadly Spheres"; script, Gardner Fox; pencils, Mike Sekowsky; inks, Bernard Sachs. December 1962.* Even the World's Greatest Super-Team had a sidekick: honorary member Snapper Carr, a hipster who chronicled the JLA's adventures in their giant casebook and who habitually popped his fingers to show excitement. Snapper talked in a faux-beat language unlike any ever spoken in human history, but it sure was fun to read.

OS JUSTICEIROS

Following spread: *Poster, artist unknown, 1960s.* In Brazil, the Man of Steel became Super-Homem while his Justice League teammates were known by such names as Elektron (Atom), Lanterna Verde (Green Lantern), Ajax, O Marciano (Martian Manhunter), and Miss América (Wonder Woman).

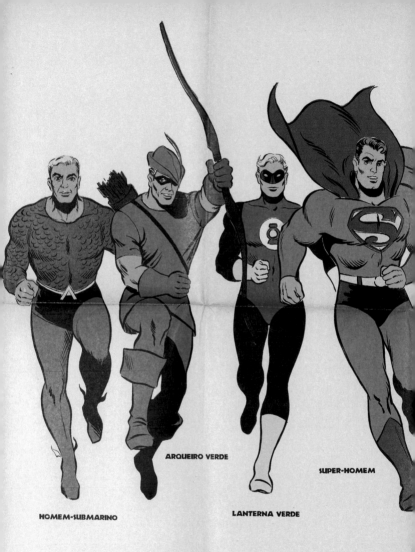

ARQUEIRO VERDE

SUPER-HOMEM

HOMEM-SUBMARINO

LANTERNA VERDE

EDITORA BRASIL-AMÉRICA

Rua Gen. Almério de Moura, 302-320
Rio de Janeiro (Gb) — Brasil

Êste é
ALMANAC
NÃO PO

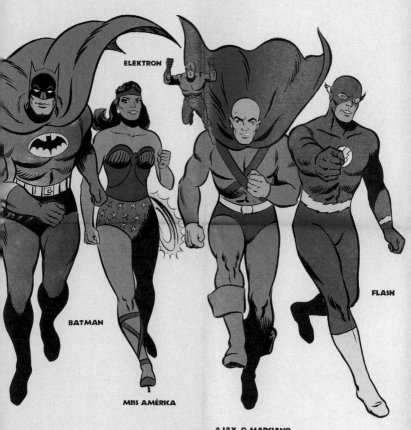

ELEKTRON

BATMAN

MISS AMÉRICA

AJAX, O MARCIANO

FLASH

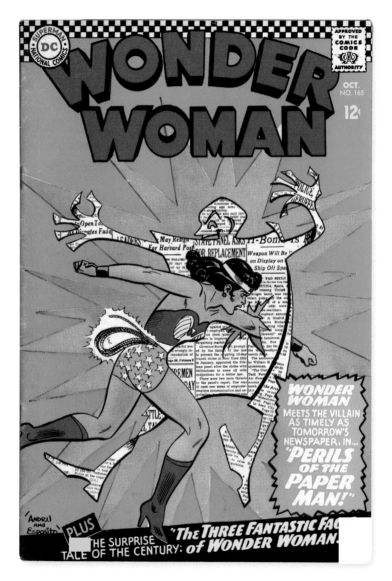

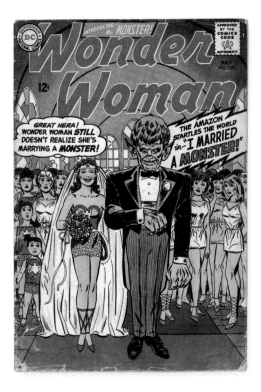

WONDER WOMAN No. 165

Opposite: *Cover art, Ross Andru and Mike Esposito, October 1966.*

WONDER WOMAN No. 155

Above: *Cover art, Ross Andru and Mike Esposito, July 1965.* With nearly 2,700 credits, Kanigher was by far the most prolific DC writer of all time. He wrote stories at terrific speed, without outlines and in a single sitting, typing as if his life depended on it and tossing in any mad, random idea that might pop into his head rather than risk slowing down. In addition to a monster groom, this issue also contained a giant ape atop the Statue of Liberty, a birdman, a merman, a mirrorless castle on an island in the sky, and a living, flying sphinx. And that's just in the first half.

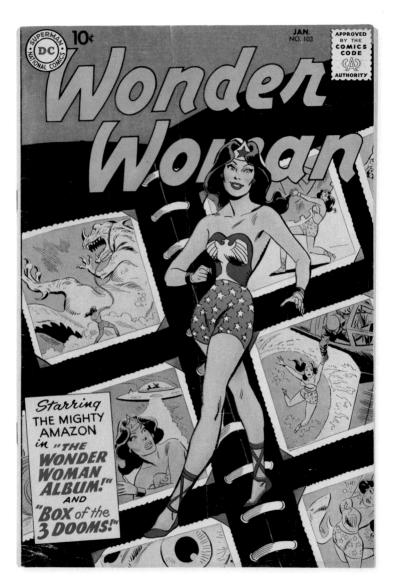

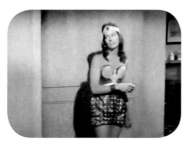
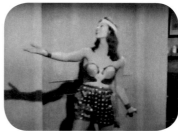
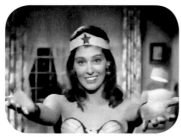

WONDER WOMAN No. 103

Opposite: *Cover art, Ross Andru and Mike Esposito, January 1959.*

WONDER WOMAN TV PILOT

Above: *Screencaps, Ellie Wood Walker and Linda Harrison, 1967.*

Wonder Woman

THREE WISHES OF DOOM!

© 1966 National Periodical Publications, Inc.

AT THE HOLLIDAY COLLEGE AUDITORIUM...

YOU WON THE CONTEST FAIRLY, INEZ! YOU DESERVE THE PRIZE! TO ASK THREE WISHES OF ME! WHAT IS YOUR FIRST WISH?

MY FIRST WISH, WONDER WOMAN, IS TO BORROW YOUR AMAZON BRACELETS, FOR AS LONG AS I WISH TO USE THEM!

GREAT HERA! I MUST KEEP MY HRAND--AND DO AS SHE DEMANDS!

NOW -- WE SHALL SEE WHO IS A WONDER WOMAN! I'M SO SURE I CAN USE THEM AS WELL AS YOU -- THAT I'LL RETURN THEM THE FIRST TIME I FAIL!

NEVER BEFORE HAS THIS HAPPENED. WHAT WILL BE THE OUTCOME?

THE NEXT MORNING, WONDER WOMAN RECEIVES AN URGENT MESSAGE FROM THE COLLEGE...

INEZ GREY IS GOING HOME FOR THE HOLIDAY! SHE'S AT MAIN STATION NOW!

GREAT HERA! AND SHE STILL HASN'T RETURNED MY BRACELETS!

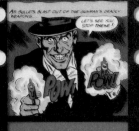

AS BULLETS BLAST OUT OF THE GUNMAN'S DEADLY WEAPONS.

LET'S SEE YOU STOP THESE!

POW! POW!

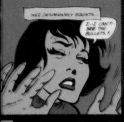

INEZ DESPERATELY SQUINTS.

I--I CAN'T SEE THE BULLETS!

HH--WHO--HH--WHAT--?

PING!

SHH -- IT'S WONDER WOMAN!

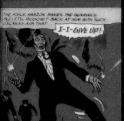

THE AGILE AMAZON MAKES THE GUNMAN'S BULLETS RICOCHET BACK AT HIM WITH SUCH UNCANNY AIM THAT...

I--I GIVE UP!

SPANG!

SPANG!

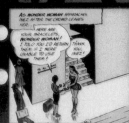

AS WONDER WOMAN APPROACHES INEZ AFTER THE CROWD LEAVES HER...

HERE ARE YOUR BRACELETS, WONDER WOMAN! I TOLD YOU I'D RETURN THEM IF I WERE UNABLE TO USE THEM!

THANK YOU, INEZ!

RELUCTANTLY, INEZ HANDS OVER...

I WISH YOU WOULD CHANGE YOUR MIND, INEZ! ASK ANY-THING--

NEXT TRAIN

FALLING FROM THE FRAME--AND RUSHING...

AND IT IS HOT WITH HER BODY! I'LL SHOW YOU HOW I PERFORM A M-- SAVING THAT WITH HER--

BUT THE LASSO IS HURTLING STEVE --

WONDER WOMAN'S LASSO--BUT--IT DIDN'T REACH ME-- I--I'M DOOMED!

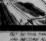

BUT BY THIS TIME HAS BECOME AWARE SHE SEIZES--

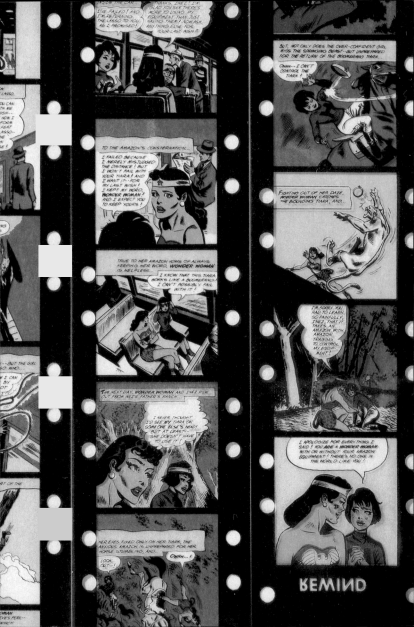

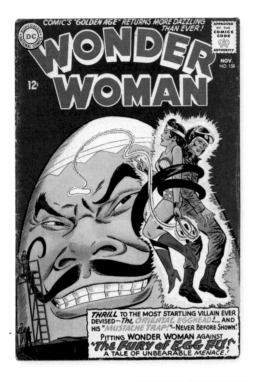

WONDER WOMAN PROJECTOR STRIP

Previous spread: *Flashy Flicker Films strips using recent comic book stories; script, Robert Kanigher; pencils, Ross Andru; inks, Mike Esposito, 1965.*

WONDER WOMAN No. 158

Above: *Cover art, Ross Andru and Mike Esposito, November 1965.*

WONDER WOMAN No. 122

Opposite: *Interior, "The Skyscraper Wonder Woman"; script, Robert Kanigher; pencils, Ross Andru; inks, Mike Esposito. May 1961.* In a stock device meant to instill vulnerability in the powerful heroine, Wonder Woman repeatedly seemed to be either shrunk to doll size and hopelessly outmatched or enlarged to a towering height that forced her to restrain her great abilities.

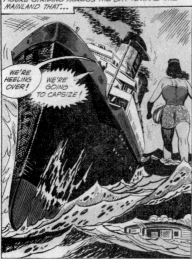

SO MASSIVE IS THE SWELL CREATED BY THE ENORMOUS FIGURE STRIDING ACROSS THE BAY TOWARD THE MAINLAND THAT...

WE'RE HEELING OVER!

WE'RE GOING TO CAPSIZE!

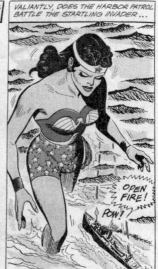

VALIANTLY, DOES THE HARBOR PATROL BATTLE THE STARTLING INVADER...

OPEN FIRE!

POW!

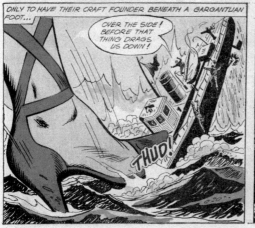

ONLY TO HAVE THEIR CRAFT FOUNDER BENEATH A GARGANTUAN FOOT...

OVER THE SIDE! BEFORE THAT THING DRAGS US DOWN!

THUD!

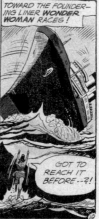

TOWARD THE FOUNDERING LINER **WONDER WOMAN** RACES!

GOT TO REACH IT BEFORE--?!

Wonder Woman

BY CHARLES MOULTON

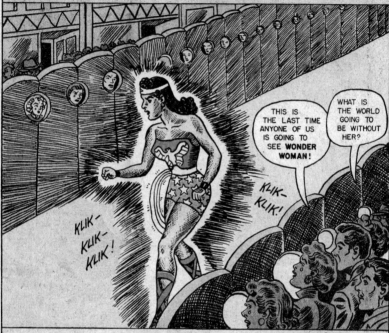

WONDER WOMAN—BEAUTIFUL AS APHRODITE, WISE AS ATHENA, SWIFTER THAN MERCURY, AND STRONGER THAN HERCULES—HAS ALWAYS FOUGHT AGAINST CRIME AND INJUSTICE! NOW—THROUGH A GRIM TWIST OF FATE, SHE BECOMES A GREATER THREAT TO INNOCENT PEOPLE THAN ANY SHE HAD FOUGHT! WHAT DO **YOU** THINK CAN BE THE SOLUTION, WHEN THE MIGHTY AMAZON UNWITTINGLY BECOMES ——————

WONDER WOMAN— *The* WORLD'S MOST DANGEROUS HUMAN!

WONDER WOMAN, No. 95, Jan., 1958 issue. Published monthly with the exception of March, June, Sept., and Dec., by NATIONAL COMICS PUBLICATIONS, INC., 2nd and Dickey Streets, SPARTA, ILL. Editorial, Executive offices and Subscriptions, 480 LEXINGTON AVENUE, NEW YORK 17, N. Y. Whitney Ellsworth, Editor. ENTERED AS SECOND CLASS MATTER at the post office at Sparta, Ill. under the act of March 3, 1879. Yearly subscription in the U. S. $1.00 including postage. Foreign, $2.00 in American funds. For advertising rates address Richard A. Feldon & Co., 205 East 42nd St., New York 17, N. Y. ©1957 by National Comics Publications, Inc. All rights reserved under International and Pan-American Copyright Conventions. Except for those who have authorized use of their names, the stories, characters and incidents mentioned in this periodical are entirely imaginary and fictitious, and no identification with actual persons, living or dead is intended or should be inferred.

Printed in U.S.A.

WONDER WOMAN No. 95

Opposite: *Interior, "Wonder Woman — The World's Most Dangerous Human"; script, Robert Kanigher; art, H.G. Peter. January 1958.*

WONDER WOMAN No. 170

Below: *Interior, "Wonder Woman — Gorilla"; script, Robert Kanigher; pencils, Ross Andru; inks, Mike Esposito. May 1967.*

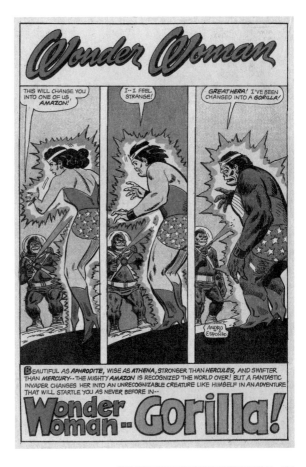

WONDER WOMAN No. 145

Left: *Interior, "The Phantom Sea Beast";
script, Robert Kanigher; pencils, Ross
Andru; inks, Mike Esposito. April 1964.*

WONDER WOMAN No. 124

Opposite: *Cover art, Ross Andru and
Mike Esposito, August 1961.*

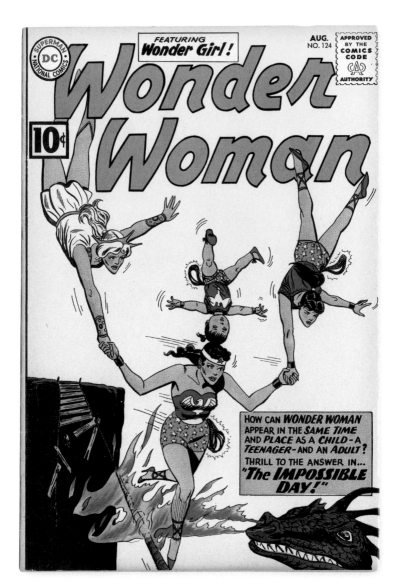

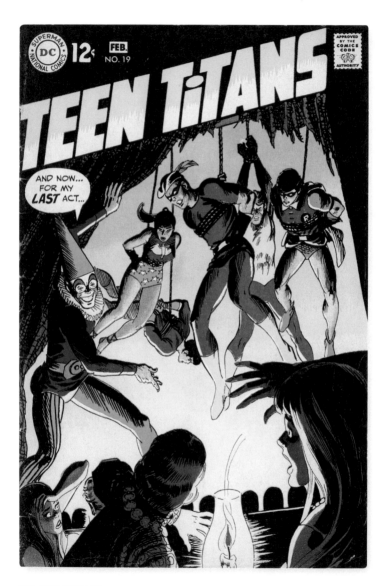

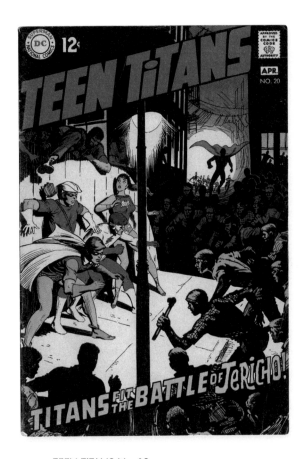

TEEN TITANS No. 19

Opposite: *Cover art, Nick Cardy, January–February 1969.* After years of scripts by a middle-aged man, the Teen Titans were revitalized by young writers who were barely out of their teens themselves. 19-year-old Mike Friedrich penned only one TT tale but had healthier runs on the *Justice League* series and the Robin backup stories in *Batman*.

TEEN TITANS No. 20

Above: *Cover art, Nick Cardy, March–April 1969.*

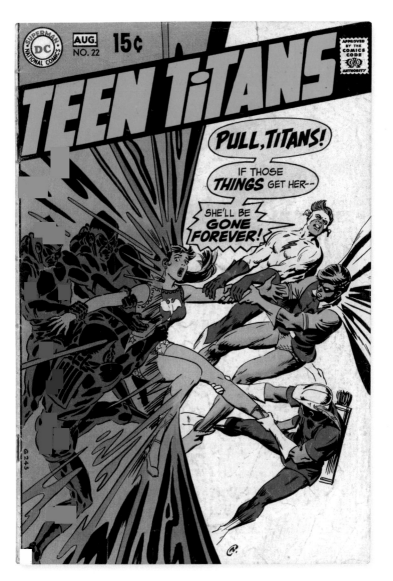

TEEN TITANS No. 22

Opposite: *Cover art, Nick Cardy, July – August 1969.* Wonder Girl finally revealed her origin at the end of this issue — she was an orphan rescued as an infant by Wonder Woman and raised among the Amazons of Paradise Island — and traded in her bathing suit for a contemporary red costume.

JUSTICE LEAGUE OF AMERICA No. 7

Above: *Interior, "The Cosmic Fun-House"; script, Gardner Fox; pencils, Mike Sekowsky; inks, Bernard Sachs. October – November 1961.* Subjected to the shape-shifting distortions of an alien mirror, the Justice Leaguers were powerless to fight back against extra-terrestrial invaders. Ultimately, Green Lantern's power ring saved the day — again. In fact, it had solved the JLA's problems so many times that the first time Green Lantern *wasn't* the hero of the moment, he actually got a little defensive.

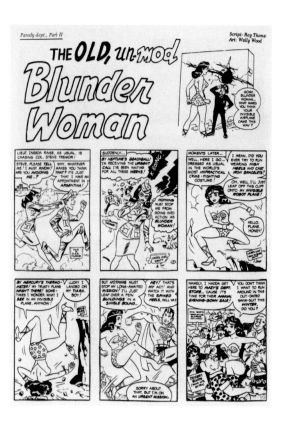

BLUNDER WOMAN

Above: *Interior, "The Old, Un-Mod Blunder Woman": script, Roy Thomas; pencils and inks, Wally Wood; cover concept, Len Brown and Art Spiegelman, 1967.* Like the 1954 *MAD* take-off that ended with Wonder Woman married with kids, the punch line of this parody put the character in a cliché female role. Published before DC revamped the Amazing Amazon, the gag also anticipated the series' newfound interest in fashion.

WONDER WOMAN No. 178

Opposite: *Interior, "Wonder Woman's Rival": script, Denny O'Neil; pencils, Mike Sekowsky; inks, Dick Giordano. September–October 1968.*

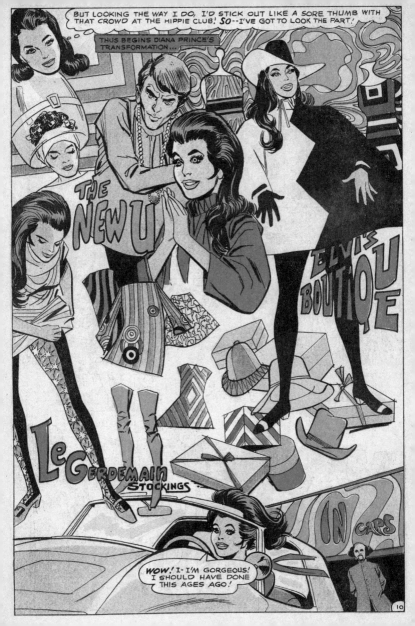

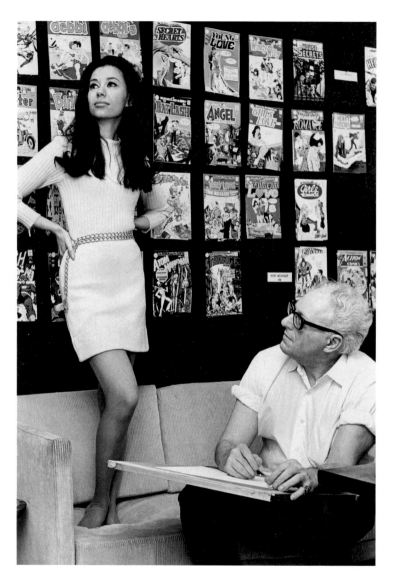

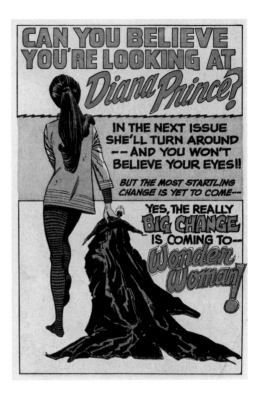

WONDER WOMAN MODEL

Opposite: *Photograph, Joyce Miller (as Diana Prince) and artist Mike Sekowsky, 1969.* In a publicity shot touting Wonder Woman's radical remake, artist Mike Sekowsky sketches a model in front of a wall of comic book covers in Carmine Infantino's office.

THE REALLY BIG CHANGE IS COMING . . .

Above: *Interior ad art, Mike Sekowsky and Dick Giordano. July – August and September – October 1968.* "At the time, I thought I was serving a feminist agenda.... I thought if she did something to earn her power, it would make her more admirable." — Dennis O'Neil

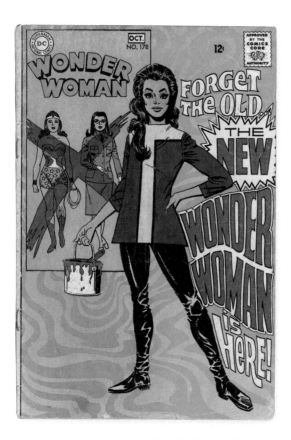

WONDER WOMAN No. 178

Above: *Cover art, Mike Sekowsky and Dick Giordano, September–October 1968.* As a precursor to the introduction of the de-powered Wonder Woman, Diana Prince got an extreme makeover. "The old costume may have seemed outmoded at the time," Les Daniels wrote, "but nothing looks as quaint today as these hip outfits."

TEEN TITANS No. 23

Opposite: *Cover art, Nick Cardy, September–October 1969.* Ditching her ponytail and swimsuit for a stylish sleeveless number, Wonder Girl seemed to age a couple years overnight.

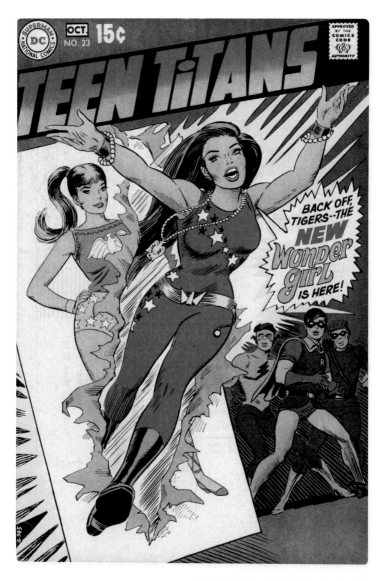

WONDER WOMAN

JULY/1972

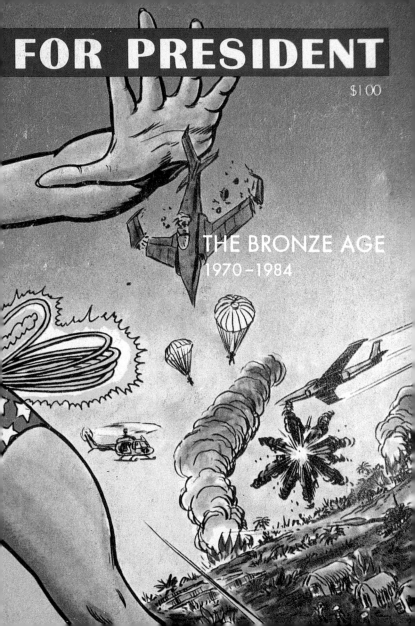

FOR PRESIDENT

$1.00

THE BRONZE AGE

1970–1984

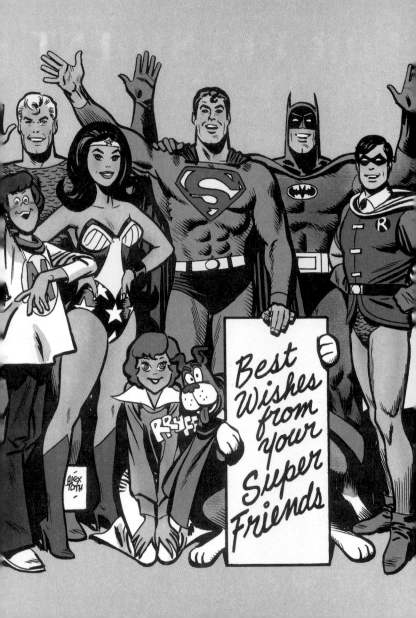

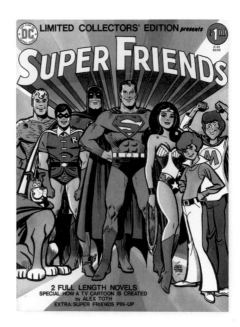

MS. MAGAZINE No. 1

Previous spread: *Cover art, Murphy Anderson, July 1972.*

LIMITED COLLECTORS' EDITION No. C-41

Opposite: *Back cover art, Alex Toth, December 1975–January 1976.* "Many of our viewers haven't started reading comics yet—or started reading at all, for that matter—but they recognize Superman and Batman. I don't know exactly where or when such young kids learn about the characters; maybe they're just born knowing them." —Joseph Barbera. As DC wrestled with the growing sense that the comics readership was dramatically different from the children's television audience, its attempts to exploit its Super Heroes' unprecedented exposure in *Super Friends* often seemed confused. Toth was the show's main character designer, yet these figures are "off-model" in animation terms. They're obviously less "cartoony" than the show's actual designs, displaying the more detailed modeling in inks known as "feathering."

LIMITED COLLECTORS' EDITION No. C-41

Above: *Front cover art, Alex Toth, December 1975–January 1976.*

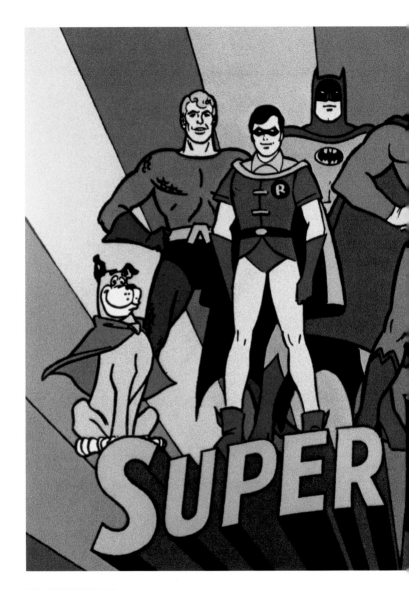

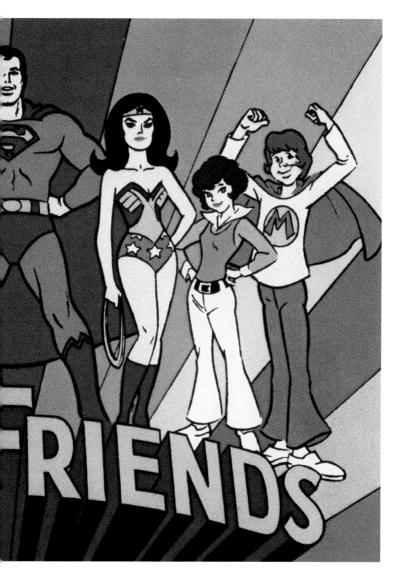

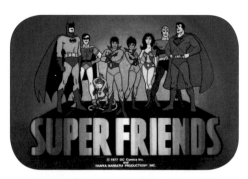

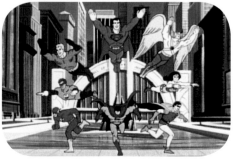

SUPER FRIENDS TITLE CEL

Previous spread: *Wonder Dog, Aquaman, Robin, Batman, Superman, Wonder Woman, Wendy, and Marvin, 1973.* The increasing disconnect between the audience for cartoon "kidvid" and the older comics fan base was becoming apparent. TV's smash-hit Justice League for juveniles did not confer its success on its comics adaptation.

ALL-NEW SUPER FRIENDS HOUR

Above: *Animated title sequence, Hanna-Barbera, 1977 and 1978.*

SUPER HEROES AT SEA WORLD

Opposite: *Showbook cover, 1976.* The DC Super Heroes aquatic spectacle was a pricey enterprise. The costuming expense of the 1976 Sea World production came to $40,000. To the producers' horror, the elastic in the spandex and foam outfits melted after going through a clothes dryer. A special drying room was subsequently built to avoid similar disasters.

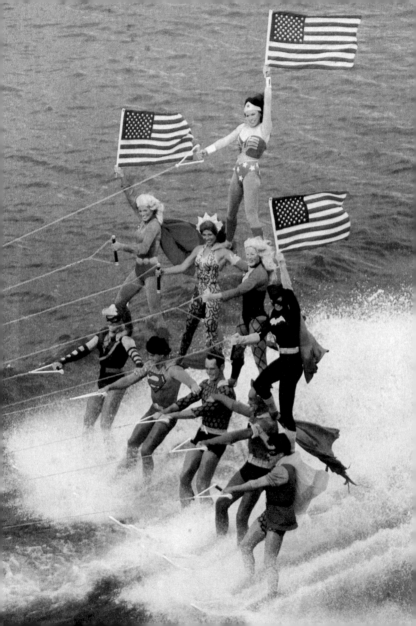

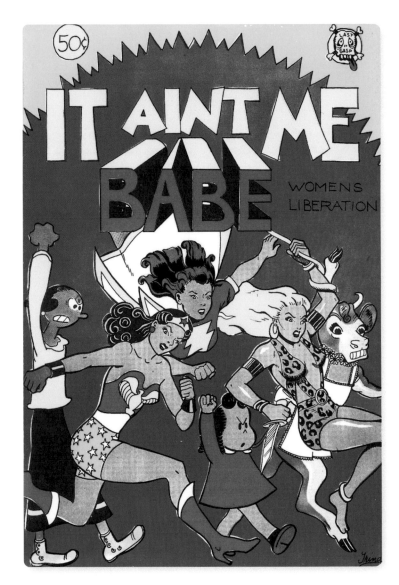

IT AIN'T ME BABE

Opposite: *Cover art, Trina Robbins, July 1970.* A devoted fan of Wonder Woman and other female heroines in her youth, Trina Robbins became a pioneer in the underground comic movement and spearheaded *It Ain't Me Babe*, a comic book featuring nothing but female creators. In 1986, Robbins became the first female to draw a full-length Wonder Woman solo story.

ENOUGH WITH THIS SECOND SEX BUSINESS, SUPERMAN!

Below: *Newspaper clipping,* Daily News: *art, José Luis Garcia-López and Dan Adkins. January 20, 1978.* A co-opted image from the recent Superman vs. Wonder Woman tabloid comic book illustrated its point about gender inequality among Super Heroes.

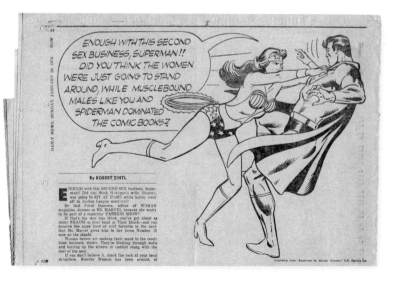

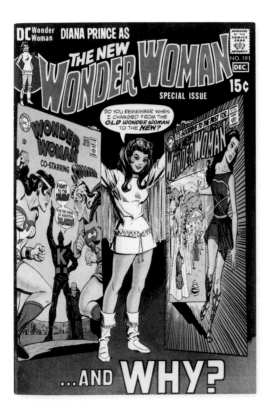

WONDER WOMAN No. 191

Above: *Cover art, Mike Sekowsky and Dick Giordano, November–December 1970.* The transformation of Wonder Woman from costumed crime fighter to mod heroine coincided with the rise of artist-driven series. Initially a co-plotter and artist on *Wonder Woman*, Mike Sekowsky rose quickly to become editor and writer as well, bringing his talent to bear on established features and new creations alike.

WONDER WOMAN No. 199

Opposite: *Interior, "Tribunal of Fear"; script, Denny O'Neil; pencils, Don Heck; inks, Dick Giordano; March–April 1972.* A student of Eastern philosophy and meditation, O'Neil occasionally drew on sources like Richard Hittleman's books on yoga for his scripts.

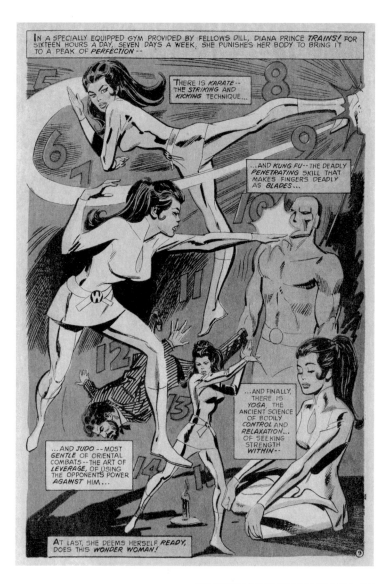

WONDER WOMAN No. 190

Below: *Cover art, Mike Sekowsky and Dick Giordano,
September – October 1970.*

WONDER WOMAN No. 189

Opposite: *Cover art, Mike Sekowsky and Dick Giordano,
July – August 1970.*

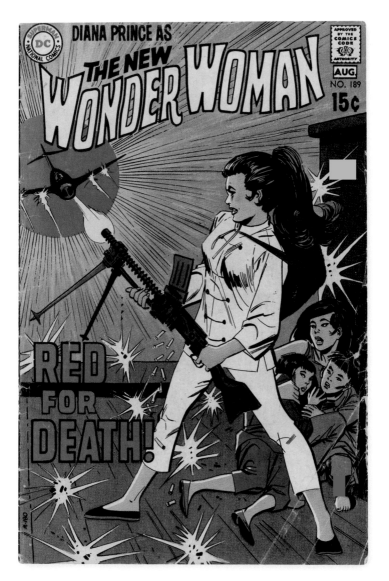

WONDER WOMAN No. 201

Above: *Cover art, Dick Giordano, July – August 1972.*

WONDER WOMAN No. 207

Opposite: *Cover art, Ric Estrada and Vince Colletta, August–September 1973.* After initially writing all-new plots, Kanigher looked to the past for inspiration. For five consecutive issues, *Wonder Woman* featured rewritten 1940s stories, marking time before editor Julius Schwartz stepped in to modernize the heroine.

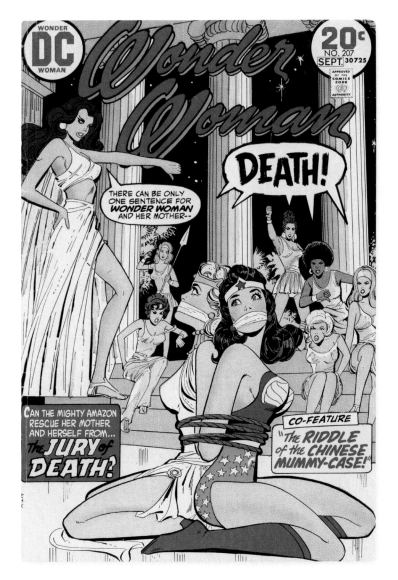

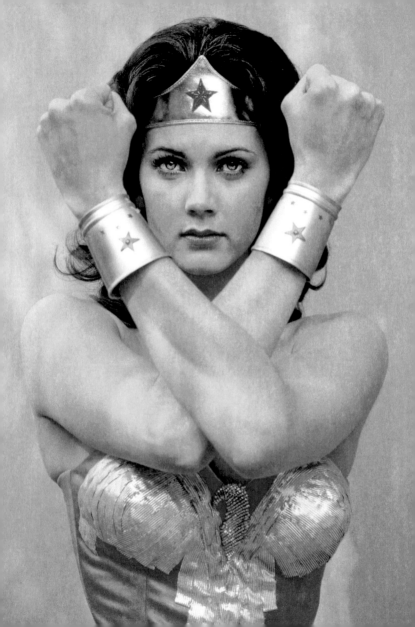

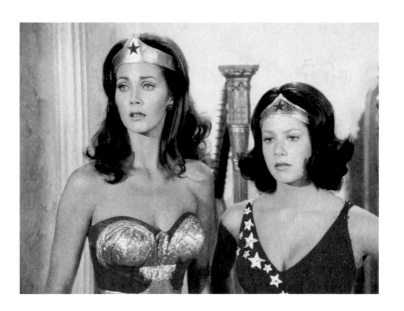

WONDER WOMAN

Opposite: *Film still, Lynda Carter, 1975.*

ENTER WONDER GIRL

Above: *Television still, Carter with Debra Winger as Wonder Girl, "The Feminum Mystique," 1976.* In the comics, Wonder Girl began as Princess Diana's younger self, then became the costumed persona of Donna Troy, of the Teen Titans. On TV, she was Wonder Woman's younger sister, Drusilla, seen in three episodes in the person of Debra Winger, making her professional acting debut. Beating the odds, Winger survived her beginnings to become a critically acclaimed, Oscar-nominated star.

WONDER WOMAN No. 205

Above: *Interior, "Target Wonder Woman"; script, Robert Kanigher; pencils, Don Heck; inks, Bob Oksner. March–April 1973.* After five years and 26 issues without a costumed star, *Wonder Woman*'s domestic sales were no better than they had been before DC decided that her star-spangled attire was a liability. Longtime writer-editor Bob Kanigher, returning to DC after an extended sabbatical, restored the Amazon's super-powered incarnation in stories like this one.

WONDER WOMAN No. 239

Opposite: *Interior, "A Duke Named Deception"; script, Gerry Conway; pencils, Jose Delbo; inks, Vince Colletta. January 1978.* Subjected to illusions like a marauding Statue of Liberty, the WWII–era Wonder Woman aroused suspicions among military leaders already wary of a female who possessed so much power and influence.

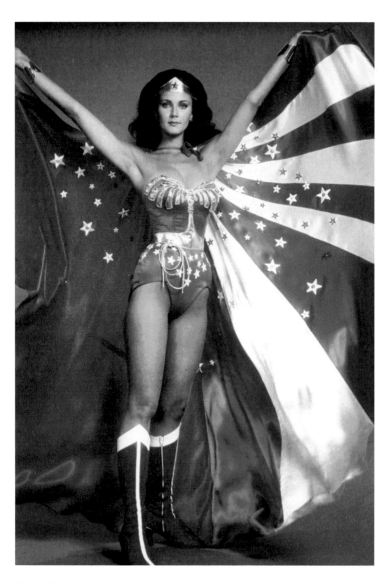

LYNDA CARTER AS WONDER WOMAN

Opposite: *Promotional photo,* Wonder Woman *television show, ca. 1976.* "Strength and beauty and intelligence and compassion…she was sort of like the ideal woman. More like an archetype of a woman." —Lynda Carter

WONDER WOMAN No. 291

Below: *Interior, "Judgment in Infinity"; plot, Paul Levitz; script, Roy Thomas; pencils, Gene Colan; inks, Frank McLaughlin. May 1982.*

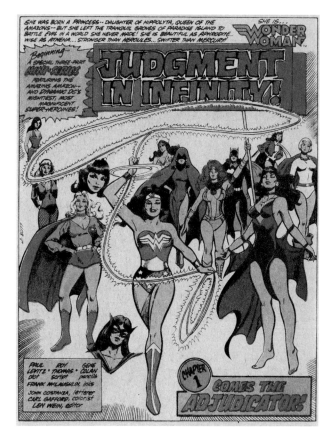

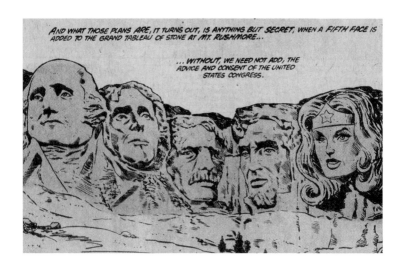

WONDER WOMAN No. 300

Above: *Interior, "The Power That Corrupts"; script, Roy and Danette Thomas; pencils and inks, Keith Pollard. February 1983.*
The milestone 300th issue imagined several alternate paths the heroine's life might have taken, from wife and mother to reluctant queen of the Amazons to a power-mad public enemy who added her face to Mount Rushmore.

ALL-NEW COLLECTORS' EDITION No. C-54

Opposite: *Cover art, José Luis García-López and Dan Adkins, 1978.*
The discovery of García-López in 1975 gave DC a new interpreter of Superman. He may not have been as naturalistic and emotive as veteran Curt Swan, but his action scenes were more powerful, making him perfect for the tabloid-size specials.

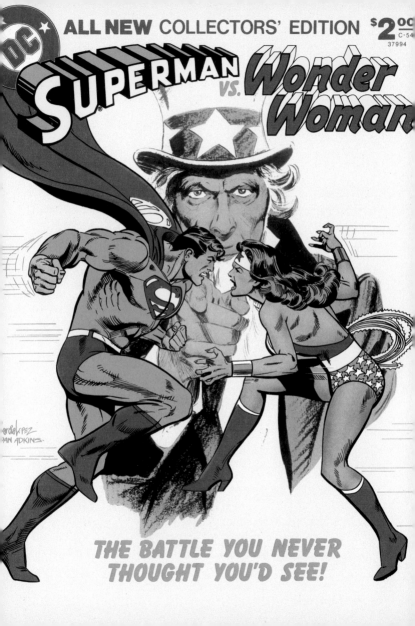

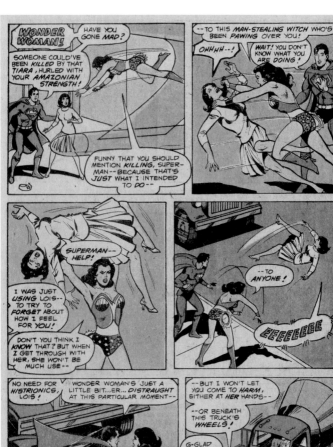

DC COMICS PRESENTS No. 32

Opposite and above: *Interior, "The Super-Prisoners of Love"; plot, Gerry Conway; script, Roy Thomas; pencils, Kurt Schaffenberger; inks, Vince Colletta. April 1981.* The jealousy that characterized the Silver Age Lois Lane had given way to a more mature, level-headed persona as the 1970s wore on. By 1981, old-school conflict required machinations from the likes of the love god Eros, who created a fiery attraction between Superman and Wonder Woman . . . While never a serious consideration, a romance between Superman and Wonder Woman was often teased in stories. A 1971 issue of *World's Finest* even matched Clark Kent and Diana Prince through a computer dating service.

DC 100-PAGE SUPER-SPECTACULAR No. 6

Following spread: *Cover art, Neal Adams, 1971.* Fans marveled at 34 carefully rendered figures on the wraparound cover of the "World's Greatest Super Heroes," all of whom were identified with capsule descriptions on the inside back cover. As a bonus, editor E. Nelson Bridwell also compiled a comprehensive list of all of DC's costumed heroes to date—and their first appearances—that was interspersed throughout the issue.

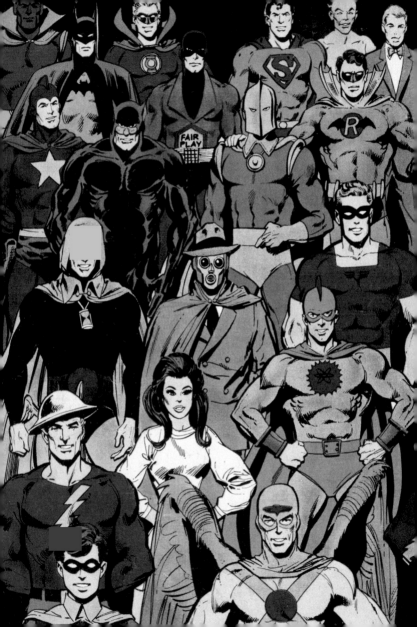

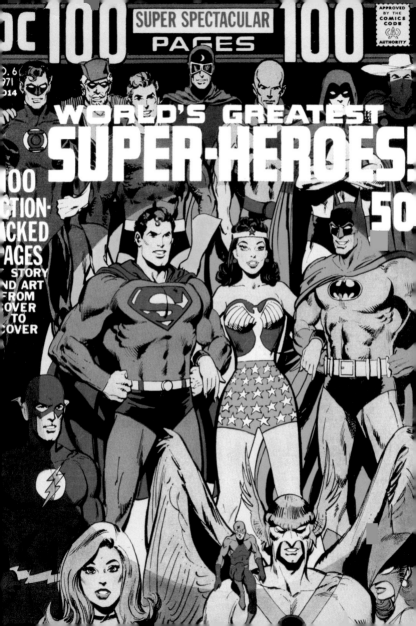

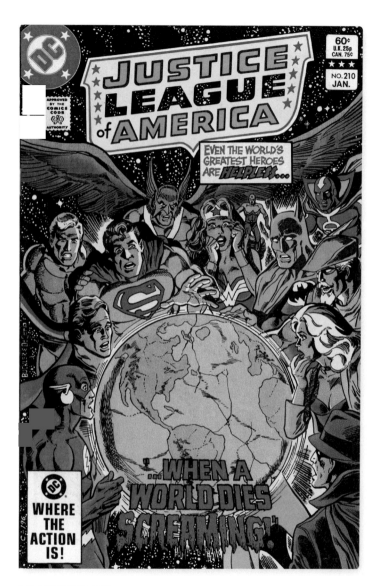

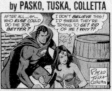
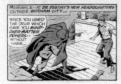

JUSTICE LEAGUE OF AMERICA No. 210

Opposite: *Cover art, Rich Buckler and Mike De Carlo, January 1983.* A 72-page JLA story, originally intended for publication in 1978, was finally serialized over three issues of the regular comic book, beginning with this one.

THE WORLD'S GREATEST SUPERHEROES

Above: *Newspaper strip: script, Martin Pasko; pencils, George Tuska; inks, Vince Colletta. September 10, 1978.*

THE WORLD'S GREATEST SUPERHEROES

Following spread: *Newspaper strip: script; Martin Pasko; pencils, George Tuska; inks, Vince Colletta. April 9, 1978.* Several years after the cancellation of the "Batman" newspaper strip, DC returned to that arena with a feature starring the Justice League of America and other heroes like Robin and Black Lightning. The focus shifted to Superman in 1979 to capitalize on the blockbuster movie but heroes like Batman, Wonder Woman, and the Flash continued to guest-star for a time. Ultimately re-titled "Superman," the strip ended in 1985.

SUPERMAN

THE WORLD'S GREATEST
SUPERHEROES

WONDER WOMAN

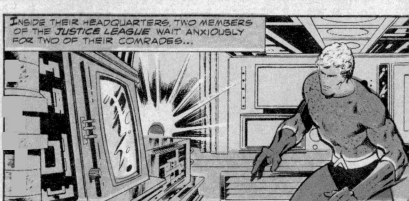

INSIDE THEIR HEADQUARTERS, TWO MEMBERS OF THE *JUSTICE LEAGUE* WAIT ANXIOUSLY FOR TWO OF THEIR COMRADES...

...AND *AQUAMAN--KING OF THE SEVEN SEAS --* WHO COMMANDS THE DENIZENS OF THE DEEP WITH HIS *TELEPATHIC POWERS...*

Pasko
Tuska
Colletta

AND THE CAUSE OF THE WARHEAD -- SPEED

ACCORDING TO THE *MONITOR*, THE MISSILE WILL STRIKE IN *ONE MINUTE !*

THE FLASH

AQUAMAN

THE SATELLITE HEADQUARTERS OF THE *JUSTICE LEAGUE* IS SUSPENDED IN FIXED ORBIT 22,300 MILES OVER THE *U.S.A.* ...

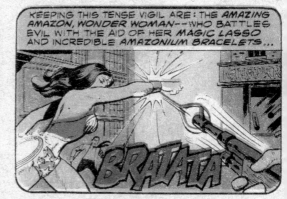

KEEPING THIS TENSE VIGIL ARE: THE *AMAZING AMAZON, WONDER WOMAN*--WHO BATTLES EVIL WITH THE AID OF HER *MAGIC LASSO* AND INCREDIBLE *AMAZONIUM BRACELETS* ...

BRATATA

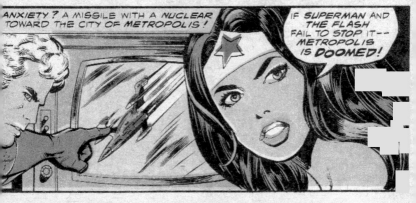

ANXIETY? A MISSILE WITH A *NUCLEAR* TOWARD THE CITY OF *METROPOLIS* !

IF *SUPERMAN* AND THE *FLASH* FAIL TO *STOP* IT-- *METROPOLIS* IS *DOOMED* !

DC COMICS PRESENTS No. 41

Below: *Interior, "A Bold New Direction for . . . Wonder Woman";
script, Roy Thomas; pencils, Gene Colan; inks, Romeo Tanghal.
January 1982.* Designed to promote female equality in society,
the Wonder Woman Foundation also impacted its namesake
when the Amazing Amazon replaced the eagle design on her
costume with the group's symbol. Not coincidentally, the "WW"
design was also more readily licensed.

THE SUPER DICTIONARY

Opposite: *Book cover art, Joe Kubert, 1978.* Using DC heroes to
help define words, *The Super Dictionary* also incorporated
several ethnically diverse characters used in other Warner
Educational projects. Joe Orlando and his team also designed
a weighty study guide to accompany the dictionary in schools,
but it never made it past the prototype stage.

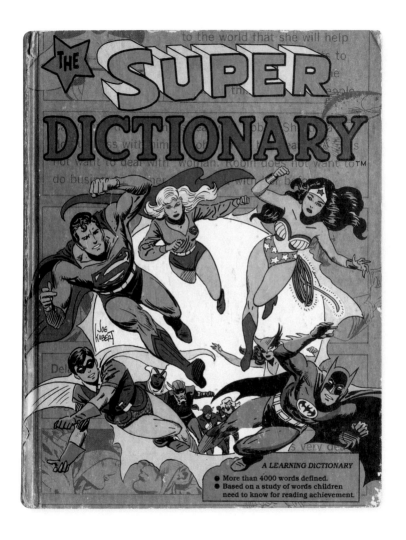

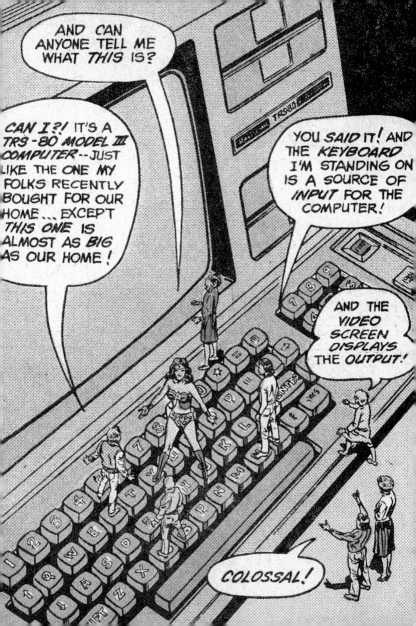

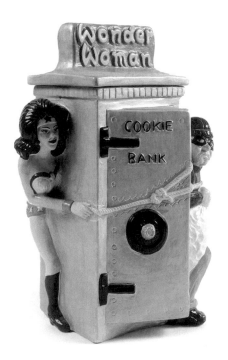

COMPUTER WHIZ-KIDS

Opposite: *Interior, "The Computer Masters of Metropolis"; script, Paul Kupperberg; pencils, Curt Swan; inks, Frank Chiaramonte. 1982.* DC partnered with Radio Shack to produce an annual series of giveaway comic books that simultaneously educated readers about computers while pitching the TRS-80 unit. Superman starred in the 1980-1982 editions — but "whiz kids" Alec and Shanna were the representative reader stand-ins in each story. After production of the giveaways left DC, the two youngsters became the stars of the series, continuing into the early 1990s.

SAFE KEEPING

Above: *Wonder Woman cookie jar, 1978.* Thanks to Wonder Woman's prominence on TV in the 1970s, licensed products proliferated during the latter half of the decade. The Amazon Princess's likeness could be found on cookie jars, placemats, mirrors, sleeping bags, lamps, lunchboxes, and even a specially molded cake pan.

80% of adults read newspaper comic strips.*

90% of our children are regular readers of comic books.*

Seven out of ten school-age readers feel that comics have improved their reading comprehension.**

80% of 36 leading companies stated: "Comics are extremely effective PR and Marketing tools."*

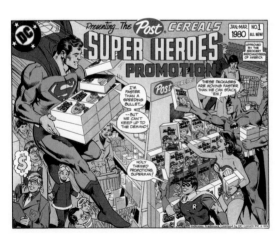

50% of this same group say more people read their promotional comics than any other of their marketing material.*

67% of these companies believe comics are educational...70% say comics are effective in changing customer attitudes.*

Sources:
* "Study of Comics as PR Tool in Communications."
—Marvin J. Migdol

** "Study of DC Comics Readers" —Mark Clements Research, Inc.

LET US START WORKING FOR YOU!

Above: *Promotional brochure; art, José Luis García-López and Dick Giordano; 1979.* Hoping to attract clients for company specific promotional comics, DC produced a handsome 8-page brochure filled with testimonials and colorful artwork.

POST CEREALS PROMOTION

Opposite: *Advertising art, Dick Giordano, 1980.* DC's late 1970s partnership with Post Cereals included mini-comic premiums in boxes of Fruity Pebbles (1979) and Super Sugar Crisp (1980) as well as posters.

JUSTICE LEAGUE OF AMERICA No. 184

Opposite: *Interior, "Crisis Between Two Earths, or Apokolips Now"; script, Gerry Conway; pencils, George Pérez; inks, Frank McLaughlin. November 1980.* The innovative composition and painstakingly detailed rendering seen here were the hallmarks of Pérez's work, which helped make *The New Teen Titans* a success. He had also hoped to draw for JLA but acquired the assignment under tragic circumstances when the title's regular penciller, Dick Dillin, unexpectedly died.

JUSTICE LEAGUE OF AMERICA No. 214

Above: *Interior, "The Siren Sisterhood"; script, Gerry Conway; pencils, Don Heck; inks, Romeo Tanghal. May 1983.* Following George Pérez's run, veteran Don Heck became the title's new penciler. While not the superstar fan-favorite that Pérez was, Heck brought stability and solid storytelling to JLA, resulting in an 8.5% sales increase during his first year on the book.

WONDER WOMAN No. 292

Below: *Cover art, Ross Andru and Dick Giordano, June 1982.*
Wonder Woman's team-up with "just about everybody"
included a distinctive 40s-retro trade dress that included
the appearance of a hardcover book's spine.

WONDER WOMAN No. 315

Opposite: *Cover art, Paris Cullins and Dick Giordano, May 1984.*
The final years of the original *Wonder Woman* comic book
challenged the heroine's vision of herself and her history. Over
the course of 1984, she discovered an offshoot race of Amazons
in South America and learned that key memories of her past
had been erased or altered by her mother Queen Hippolyta.

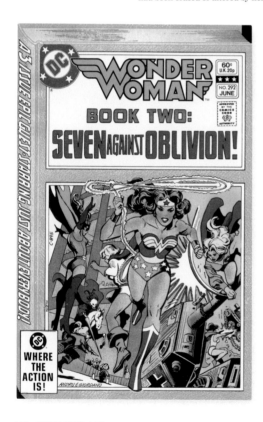

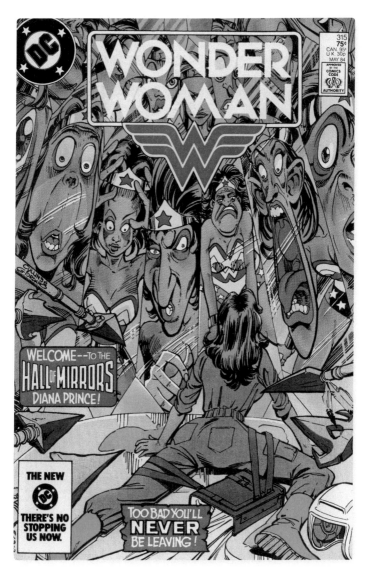

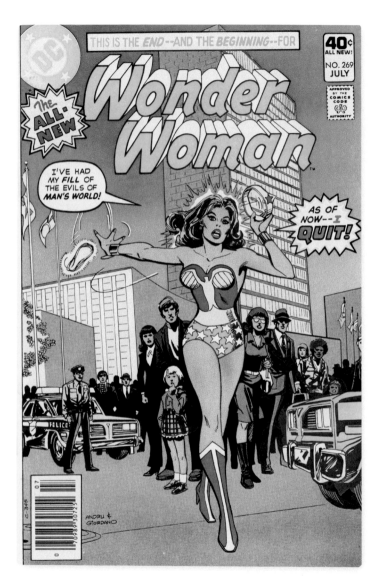

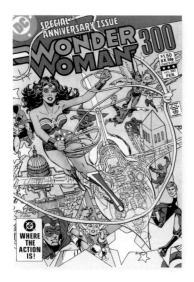

WONDER WOMAN No. 269

Opposite: *Cover art, Ross Andru and Dick Giordano, July 1980.*

WONDER WOMAN No. 300

Above left: *Cover art, Ed Hannigan and Dick Giordano, February 1983.* Wonder Woman's tricentennial issue was notable not only for an extra-length story but for its first published script credit for a woman (co-writer Dann Thomas) and first female artist on the title (Jan Duursema).

WONDER WOMAN No. 272

Above right: *Cover art, Dave Cockrum and Dick Giordano, October 1980.* A back-to-basics approach returned Wonder Woman to the intrigues of military intelligence as Diana Prince was reunited with long-absent supporting cast members Steve Trevor and Etta Candy.

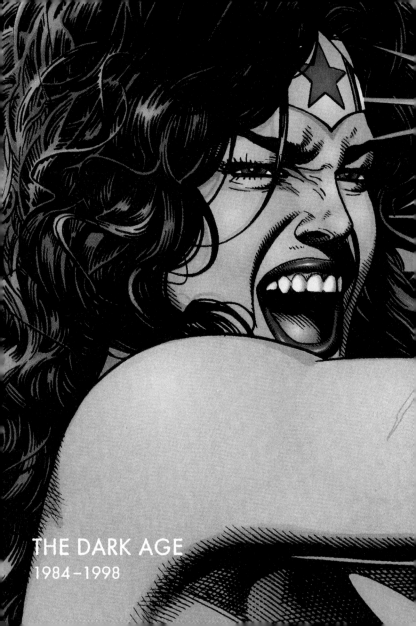

THE DARK AGE

1984–1998

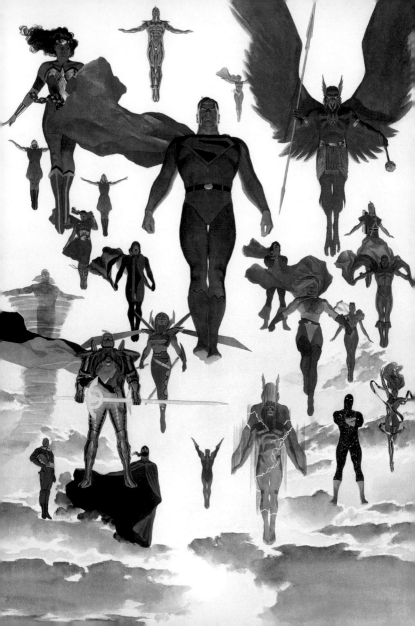

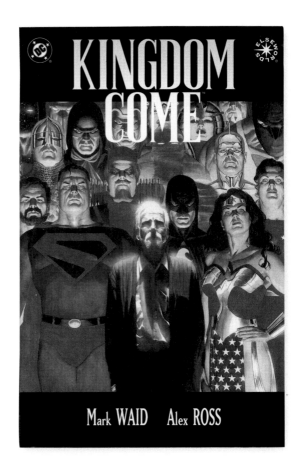

WONDER WOMAN No. 0
Previous spread: *Cover art, Brian Bolland, October 1994.*

KINGDOM COME POSTER
Opposite: *Art, Alex Ross, 1996.*

KINGDOM COME No. 2
Above: *Cover art, Alex Ross, 1996.*

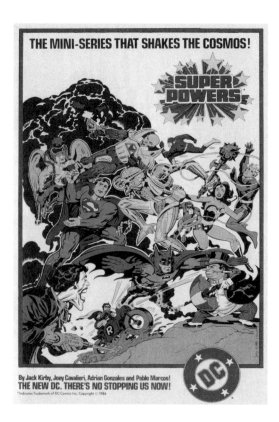

SUPER POWERS

Above: *House ad art, Jack Kirby and Mike Royer, 1984.* Although his Fourth World characters were created under an early 1970s agreement, Jack Kirby received royalties when his New Gods stories were reprinted in 1984. In a particularly inspired move, Kirby was also assigned to redesign several of his 1970s creations for Kenner's Super Powers action figures that generated a substantial amount of additional income for the legendary artist. As a tie-in to the toy line, Kirby also wrote a 1984 Super Powers mini-series, penciling covers and the entire final issue.

WONDER WOMAN No. 1

Opposite: *Cover art, George Pérez, February 1987.*

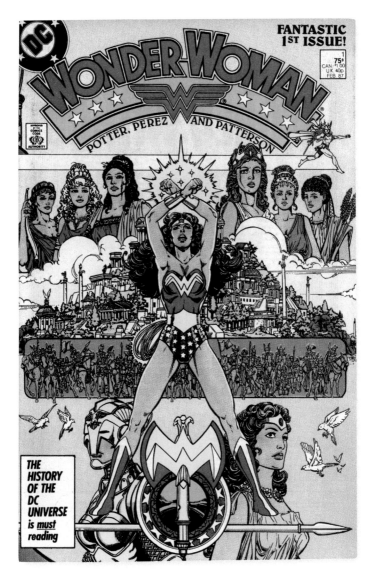

![DC logo] GENESIS 126 | $1.95 US | $2.75 CAN | OCT 97

DAILY PLANET

A METROPOLITAN NEWSPAPER SPECIAL ★★★★ EDITION Volume 1, Number 126

A WORLD WITHOUT WONDER WOMAN?

DIANA, PRINCESS OF THEMYSCIRA, STRUCK DOWN

Princess Diana of Themyscira, in her heroic garb as Wonder Woman.

EXCLUSIVE TO THE PLANET

Story and Pictures by
JOHN BYRNE

(Gateway City) While details are still sketchy, sources in the Gateway City police have confirmed that Princess Diana of Themyscira, the Amazon heroine known as Wonder Woman, was struck down yesterday in a battle with an unknown foe in downtown Gateway.

Wonder Woman was brought to the emergency room of Gateway Memorial Hospital by companions who had, reportedly, taken part in the battle that caused her injuries. According to a doctor at the hospital, Wonder Woman is not suffering from any apparent wounds, but her condition is nonetheless listed as critical.

"Frankly, we're at a loss to explain exactly what her condition is," said Dr. Warren Chin. "From what we've been able to ascertain from her companions, Wonder Woman was the victim of an attack by a... being called Neron who did no physical damage to her per se, but who struck at her very soul. This is, needless to say, unknown territory to the medical profession. Pending further tests, all we can do is sustain her physical form and hope for answers."

Members of the JLA are reportedly standing vigil by Wonder Woman's bedside.

(Story continues 2nd page following)

DIRECT SALES

WONDER WOMAN No. 126

Opposite: *Cover art, John Byrne, October 1997.* John Byrne had rebooted Superman in the late 1980s, and a decade later the writer-artist took on Wonder Woman. His striking newspaper cover helped call attention to DC's *Genesis* crossover, a four-issue series that Byrne also wrote. During its events, all of DC's godlike characters, including Darkseid and Zeus, are revealed as byproducts of a universal energy wave.

WONDER WOMAN No. 45

Below: *Cover art, George Pérez. August 1990.* Beginning with a story about mythological Pandora, Jill Thompson became the first female to regularly draw Wonder Woman. Thompson's later DC credits included *Sandman* and *The Invisibles*.

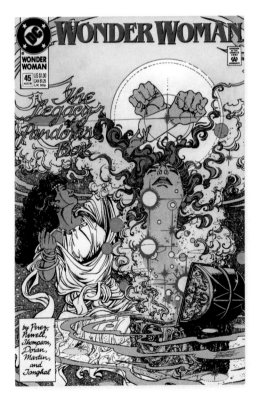

WONDER WOMAN No. 93

Above: *Cover art, Mike Deodato Jr., January 1995.*

WONDER WOMAN No. 96

Opposite: *Cover art, Brian Bolland, April 1995.* Diana may have been born on the Amazon island of Themyscira, but for much of her time in Man's World she made her home in Boston. This arrangement made it easier for guest stars to drop by, as in this tale entitled "Joker's Holiday."

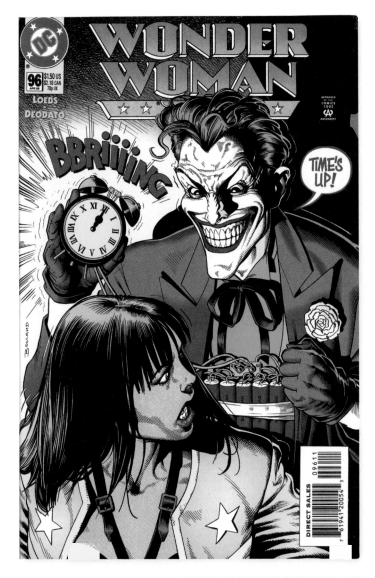

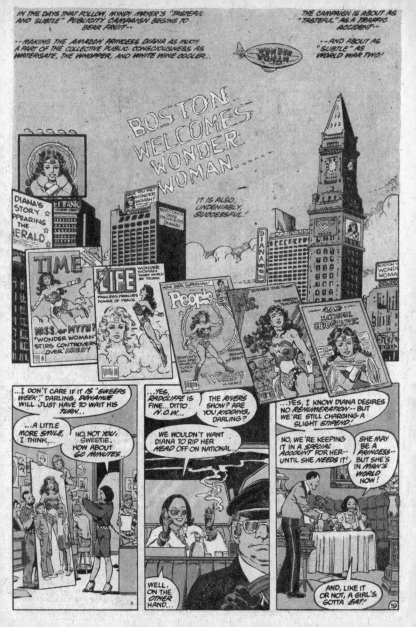

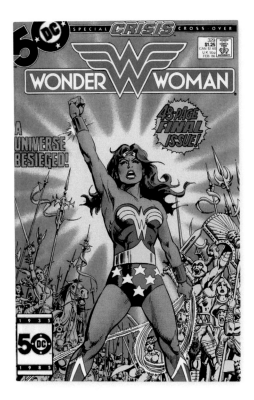

WONDER WOMAN No. 7

Opposite: *Interior, "Rebirth"; script, Len Wein; co-plotter and pencils, George Pérez; inks, Bruce Patterson. August 1987.* Following her post-*Crisis* reboot, Diana is a naive newcomer to the world beyond Paradise Island. To get her message across she enlists the help of a PR expert, but the wall-to-wall media coverage attracts the attention of the sinister Cheetah. This page by George Pérez includes '80s references to talk show hosts Phil Donahue and Joan Rivers while also referencing Wonder Woman's famous *Ms.* magazine cover.

WONDER WOMAN No. 329

Above: *Cover art, José Luis García-López. February 1986.* The final issue of Wonder Woman's original series climaxed with her marriage to Steve Trevor.

WONDER WOMAN No. 101

Below: *Cover art, John Byrne, September 1995*. Following George Pérez and William Messner-Loebs, John Byrne became the third principal writer on the rebooted *Wonder Woman* series, writing and drawing the title for three years.

WONDER WOMAN No. 62

Opposite: *Cover art, Jill Thompson and Jay Geldhof, February 1992*. After five years of guiding the modernized version of Wonder Woman, writer George Pérez bid the title an affectionate farewell.

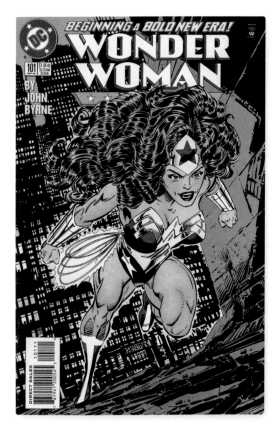

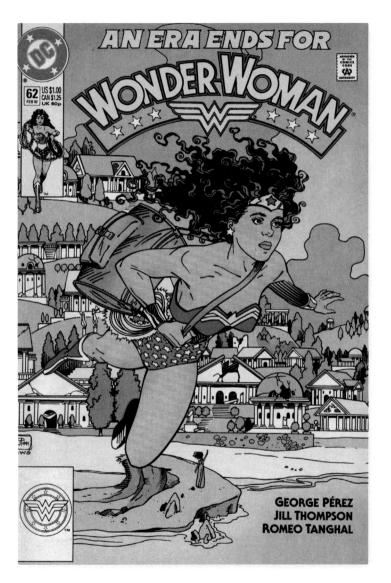

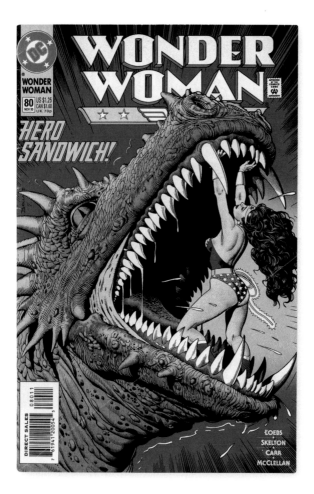

WONDER WOMAN No. 80

Above: *Cover art, Brian Bolland, November 1993.*

WONDER WOMAN No. 112

Opposite: *Interior, "Game Over"; script, pencils, and inks, John Byrne. August 1996.*

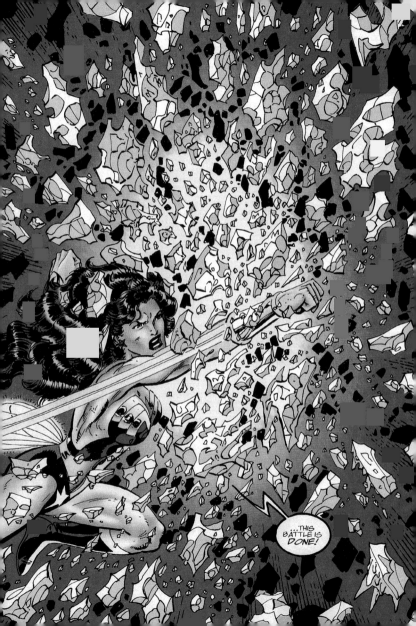

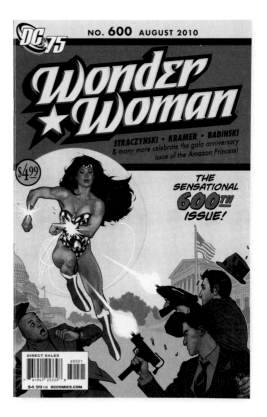

JLA/WILDC.A.T.S: CRIME MACHINE

Previous spread: *Interior, "Crime Machine"; script, Grant Morrison; pencils, Val Semeiks; inks, Kevin Conrad and Ray Kryssing. 1997.*

WONDER WOMAN No. 200

Opposite: *Interior pin-up art, Steve Rude, March 2004.*

WONDER WOMAN No. 600

Above: *Cover art, Adam Hughes, August 2010.*

PRINCESSES OF FASHION

Below: *Promotional photo, Diane von Furstenberg, Wonder Woman–inspired clothing line, 2008.* The fashion icon incorporated DC's Amazon princess into her 2008 line, with a Wonder Woman–inspired dress and a comic book featuring the Adventures of Diva, Viva, and Fifa. Said von Furstenberg, "If you feel insecure, look at yourself in the mirror and through the reflection remember to be the Wonder Woman you can be."

WONDER WOMAN No. 184

Opposite: *Cover art, Adam Hughes, October 2002.* Adam Hughes mixed modern with vintage in this cover, which adorned a Phil Jimenez tale in which Diana travels to the 1940s and meets her mother, Hippolyta, who serves as the Golden Age Wonder Woman during this point of DC continuity. The cover art echoes the style of H. G. Peter and incorporated artificial weathering effects.

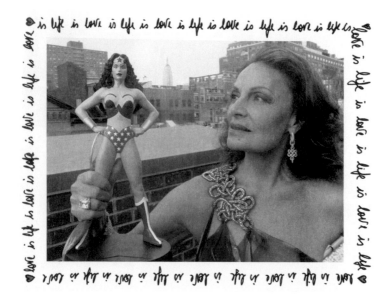

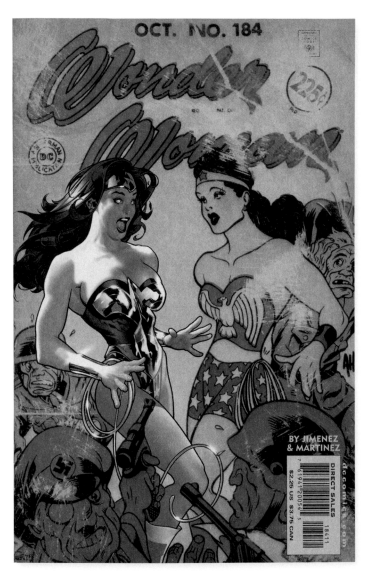

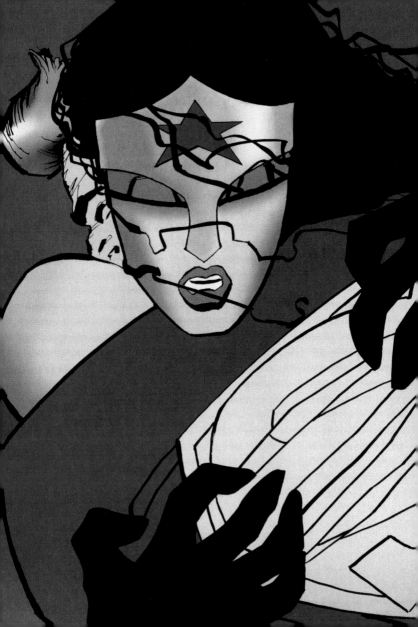

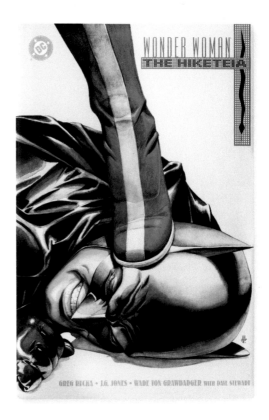

THE DARK KNIGHT STRIKES AGAIN No. 2

Opposite: *Interior, script, pencils, and inks, Frank Miller, 2002.*
In Frank Miller's interconnected *Dark Knight Returns* titles,
Wonder Woman and Superman share a passionate and often
adversarial romance. *The Dark Knight Strikes Again* is set far
in the future, in a time where Diana and Clark had produced
a 17-year old daughter named Lara. Superman and his daugh-
ter are reunited after Wonder Woman retrieves her lover from
his Arctic exile.

WONDER WOMAN: THE HIKETEIA

Above: *Cover art, J. G. Jones, June 2002.*

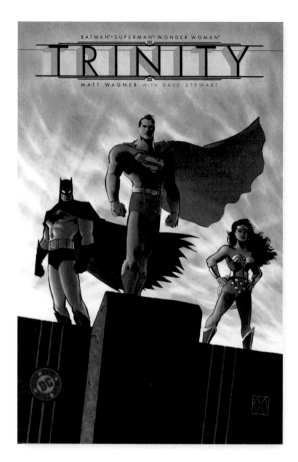

BATMAN/SUPERMAN/WONDER WOMAN: TRINITY No. 1

Above: *Cover art, Matt Wagner, August 2003.*

WONDER WOMAN No. 226

Opposite: *Cover art, J. G. Jones, April 2006.* A number of 21st-century stories examined the trinity of DC's greatest heroes, recalling their earlier friendship and the disagreements that tested it.

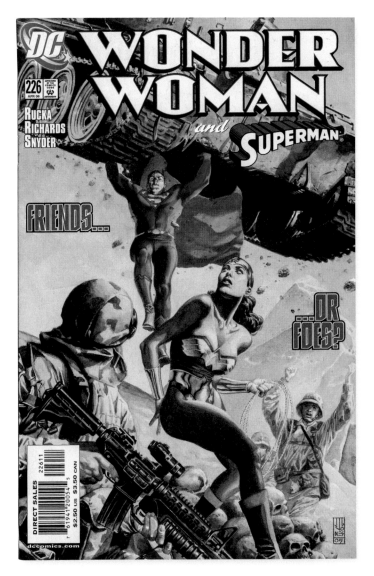

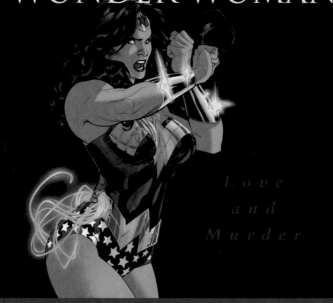

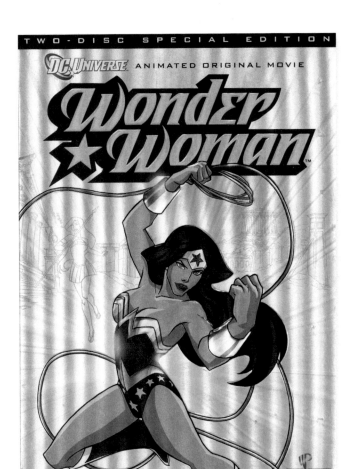

WONDER WOMAN: LOVE AND MURDER

Opposite: *Cover art, Terry and Rachel Dodson, 2007.*

WONDER WOMAN ANIMATED MOVIE

Above: *DVD cover art, Lauren Montgomery and Mark Esparza, 2009.*

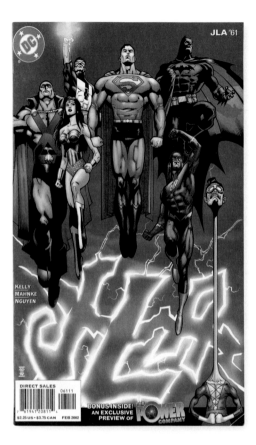

JLA No. 61

Above: *Cover art, Doug Mahnke and Tom Nguyen, February 2002.*

ALL STAR COMICS No. 2

Opposite: *Cover art, Dave Johnson, May 1999.*

THE NEW FRONTIER No. 6

Following spread: *Interior, "Epilogue"; script, pencils, and inks, Darwyn Cooke. 2004.*

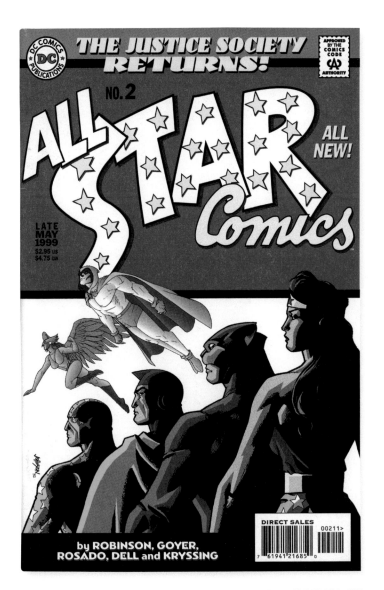

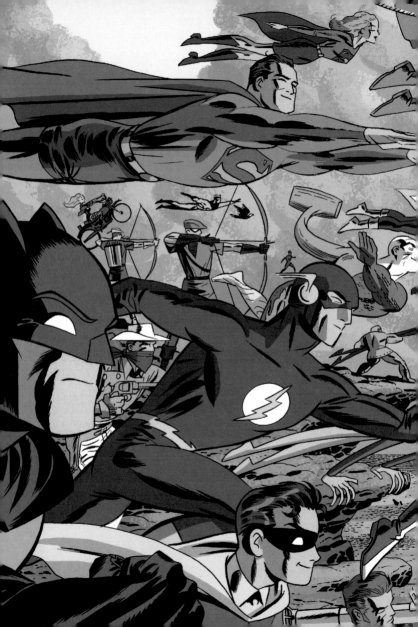

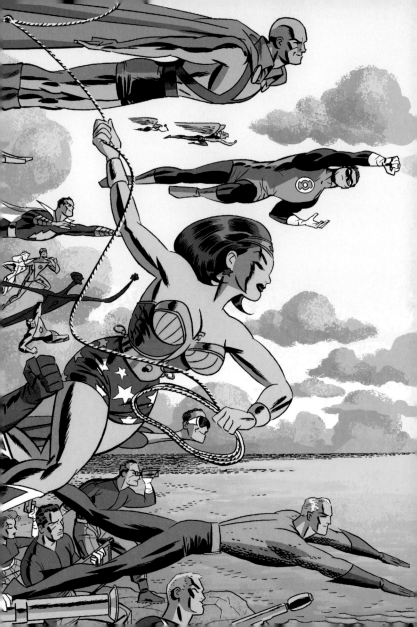

THE BIG THREE IN
YOUR POCKET

The Little Book of ...
Batman
Superman
Wonder Woman

EDITORIAL NOTE

Early comics carried few credits or often
credited creators of features rather than the
actual talent producing the stories. We've
endeavored to research credits for accuracy,
and regret any errors.

This collection is based on material from
the Eisner Award–winning *75 Years of DC
Comics*, originally published in 2010 and the
era-by-era volumes that followed.

The majority of the comics included in this
series were photographed from the Ian
Levine Collection. Also featured are the
collections of Art Baltazar, Ivan M. Briggs,
Saul Ferris, Grant Geissman, Tom Gordon,
Jim Hambrick, P. C. Hamerlinck, Philip
Hecht, Bob Joy, Chip Kidd, Peter Maresca,
Jim Nolt, Jerry Robinson, David Saunders,
Anthony Tollin, Ellen Vartanoff, Jerome
Wenker, Mark Zaid, and, notably, Bob
Bretall, Mark Waid, Heritage Auctions, and
Metropolis Comics.

Any omissions for copy or credit are
unintentional and appropriate credit will
be given in future editions if such copyright
holders contact the publisher.

Image courtesy of Bob Underwood: 25.
Image courtesy of comiclink.com: 21.
Courtesy Diane Von Furstenberg: 178.
Courtesy Heritage Auctions: 35–39, 50,
72, 76, 128, 166, 157, 169. Image courtesy
heykidscomix.blogspot.com: 54. Courtesy of
the Ivan Briggs Collection: 110. Jerry G. Bails
and Roy Thomas: 108. Courtesy Josh Baker
Collection: 86–87, 95, 99, 144–145, 147.
The Kobal Collection / Warner Bros. / DC
Comics: 130, 134. Courtesy of Ms. magazine:
114–115. Courtesy Shirley Duke: 121.
© Trina Robbins: 122.

DC STYLE GUIDE

Opposite: *Popular DC Super Heroes, art, José Luis García-López, 1982.*

WONDER WOMAN No. 21

Cover: *Cover art, H. G. Peter, January–February 1947.*

SENSATION COMICS No. 96

Page 2: *Cover art, Irwin Hasen, March–April 1950.*

WONDER WOMAN No. 90

Back cover: *Cover art, Irv Novick, May 1957.*

EACH AND EVERY TASCHEN BOOK PLANTS A SEED!

TASCHEN is a carbon neutral publisher. Each year, we offset our annual carbon emissions with carbon credits at the Instituto Terra, a reforestation program in Minas Gerais, Brazil, founded by Lélia and Sebastião Salgado. To find out more about this ecological partnership, please check: www.taschen.com/zerocarbon.

INSPIRATION: UNLIMITED CARBON FOOTPRINT: ZERO.

To stay informed about TASCHEN and our upcoming titles, please subscribe to our free magazine at www.taschen.com/magazine, follow us on Twitter, Instagram, and Facebook, or e-mail your questions to contact@taschen.com.

Editor, art direction, and design: Josh Baker, Oakland
Editorial consultants: Paul Levitz, Mark Waid, Martin Pasko, John Wells, and Daniel Wallace
Production: Stefan Klatte, Cologne
Layout: Nemuel DePaula, Los Angeles
Editorial coordination: Robert Noble, New York; Jascha Kempe, Cologne
Photography: Jennifer Patrick and Ed Fox, Los Angeles; Keith Krick, New York City
German translation: Reinhard Schweizer, Freiburg
French translation: Alice Pétillot, Bordeaux

TASCHEN GMBH

Hohenzollernring 53, D-50672 Köln
www.taschen.com

Printed in Italy
ISBN 978-3-8365-2015-7

Thanks to Martin Pasko, Mark Waid, Daniel Wallace, and especially John Wells for research and writing assistance on captions and biographies.

Special thanks to Ian Levine for allowing access to his amazing collection. Thanks as well to Bob Bretall, who holds the 2014 Guinness World Record for Largest Collection of Comic Books and freely allowed us to dive into his trove.

At DC Comics, thanks are due to Michael Acampora, Allan Asherman, Karen Berger, Roger Bonas, Georg Brewer, Richard Bruning, Mike Carlin, Christopher Cerasi, Mark Chiarello, Eddy Choi, Ivan Cohen, Dan DiDio, John Ficarra, Larry Ganem, Bob Harras, Geoff Johns, Bob Joy, Hank Kanalz, Kevin Kiniry, Jay Kogan, Jim Lee, Evan Metcalf, Connor Michel, Lisa Mills, John Morgan, Diane Nelson, Scott Nybakken, Anthony Palumbo, Frank Pittarese, Barbara Rich, Cheryl Rubin, Andrea Shochet, Joe Siegel, Bob Wayne, Scott Bryan Wilson, Michael Wooten, and Dora Yoshimoto. At Warner Bros., my thanks to Josh Anderson, Leith Adams, Ben Harper, Stephanie Mente, and Nikolas Primack.

Many thanks to the numerous individuals who helped in the production of this series of books, including Jack Adler; Doug Adrianson; Teena Apeles; Dawn Arrington; Chris Bailey; Jerry Bails; Art Baltazar; John Barton; Jerry Beck; John Benson; Steve Bingen; Arnold Blumberg; Brian Bolland; Jim Bowers; Cindy Brenner; Ivan Briggs; Jonathan Browne; Scott Byers; Steve Carey; Pete Carlsson; Mildred Champlin; Dale Cendali; Ruth Clampett; Alice Cloos; Dick Cole; Wesley Coller; Gerry Conway; Margaret Croft; Les Daniels; Dave Davis; Jack Davis; Ken DellaPenta; Joe Desris; Lee Dillon; Michael Doret; Spencer Douglas; Paul Duncan; Mallory Farrugia; Saul Ferris; Stephen Fishler; Chaz Fitzhugh; Steve Fogelson; Danny Fuchs; Neil Gaiman; Craig B. Gaines; Grant Geissman; Dave Gibbons; Frank Goerhardt; Tom Gordon; Steven P. Gorman; Jared Green; Steven Grossfeld; James Halperin; Jim Hambrick; P. C. Hamerlinck; Yadira Harrison; Chuck Harter; Philip Hecht; Jim Heimann; Joseph Heller; Andy Hershberger; Jessica Hoffman; Martin Holz; Julia Howe; Adam Hyman; Lisa Janney; Klaus Janson; Jenette Kahn; Elizabeth Kane; Chip Kidd; Kirk Kimball; Denis and Stacy Kitchen; Stefan Klatte; Todd Klein; Florian Kobler; Charles Kochman; Christopher Kosek; Keith Krick; Joe Kubert; Danny Kuchuck; Amy Kule; Paul Kupperberg; Olive Lamotte; Caroline Lee; Hannah and Alfred Levitz; Jeanette, Nicole, Philip, and Garret Levitz; Steven Lomazow; Alice and Leonard Maltin; Tony Manzella; Peter Maresca; Byrne Marston; Pete Marston; Rachel Maximo; David Mazzucchelli; Thea Miklowski; John Morrow; Mark McKenna; Ryann McQuilton; Eric Nash; Constantine Nasr; Meike Niessen; Scott Neitlich; Adam Newell; Maggie Nimkin; Robert Noble; Mark Nobleman; Jim Nolt; Erica Pak; Jennifer Patrick; Kirstin Plate; Joe Orlando; Joe Rainone; Debbie Rexing; Dennis Robert; Jerry Robinson; Alex Ross; Barry Sandoval; Mike Sangiacomo; David Saunders; Zina Saunders; Randy Scott; Susannah Scott; Jürgen Seidel; David Siegel; John Smedley; Ben Smith; Wayne Smith; Geoff Spear; Art Spiegelman; Bob Stein; Roy Thomas; Shane Thompson; Anthony Tollin; Jessica Trujillo; Ellen Vartanoff; Mark Voglesong; Mike Voiles; Phillip Wages; Chris Ware; William Wasson; Evan Weinerman; Jerry Weist; Sean Welch; Jerome Wenker; Josh White; Douglas Wheeler-Nicholson; Nicky Wheeler-Nicholson; Alex Winter; DebbySue Wolfcale; Marv Wolfman; Steve Younis; Mark Zaid; Thomas Zellers; Barry Ziehl; Marco Zivny; and Vincent Zurzolo.

And a special acknowledgment to Steve Korté, Josh Baker, and Nina Wiener, and the eagle eye of Benedikt Taschen, without whom this series of books would have been impossible.

— PAUL LEVITZ

WONDER WOMAN